Routing:

A Workshop Handbook

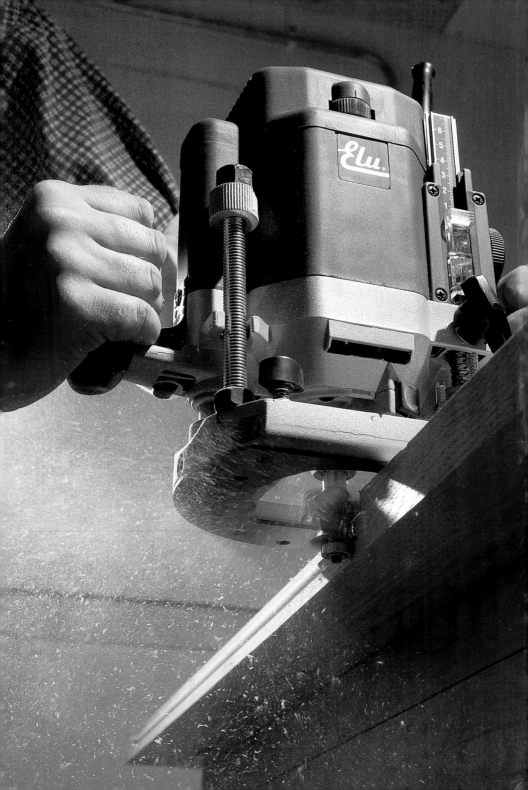

Routing:
A Workshop Handbook

Anthony Bailey

GUILD OF MASTER CRAFTSMAN PUBLICATIONS LTD

First published 2001 by
Guild of Master Craftsman Publications Ltd,
166 High Street, Lewes,
East Sussex BN7 1XU

© Anthony Bailey 2001

ISBN 1 86108 207 X

Photographs and drawings by Anthony Bailey, with additional photographs
by Paul Richardson and Alan Goodsell and the drawing on page 39 by John
Yates. Photograph of the author on page 163 by Lucy Bailey (then aged 8).

This edition is a revised and condensed version of *Routing for Beginners*,
published in 1999 by Guild of Master Craftsman Publications Ltd.

The publishers and author can accept no legal responsibility for any
consequences arising from the application of information, advice or
instructions given in this publication.

Routing consultant: Ron Fox
Designed by Wheelhouse Design
Set in Caslon and Frutiger
Colour reproduction by Viscan Graphics Pte Ltd, Singapore
Printed in Hong Kong by H&Y Printing Ltd.

To my wife, Patsy, and children, Alexander, Lucy, Amber and Francis, and to my late mother, Anne, who would have loved to have known them.

Acknowledgements

I would like to thank the following people and organizations for their help in making this book possible:

David Arscott, Stephanie Horner and Paul Richardson at the Guild of Master Craftsman Publications; Alan Arnott at the Wealden Tool Company; Paul Merry at CMT Tooling; Rochelle at Trend Ltd; and John Roberts at Robert Bosch Ltd.

Contents

	Introduction	1
1	Meet the router	2
2	Choosing a router	18
3	Router safety	26
4	Router cutters	46
5	Basic handheld operations	70
6	Jigs and templates	82
7	Inverted routing	96
8	Making joints	108
9	Dovetailing	122

Workshop projects

10	Cutter selection boards	130
11	Portable router storage case	134
12	Small router table	138
13	Large router table	142
14	Board cutting facility	150
15	T Square cutting jig	154

Glossary	158
Metric conversion table	162
About the author	163
Index	164

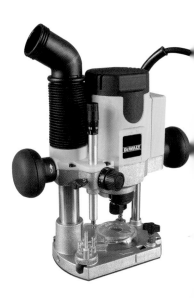

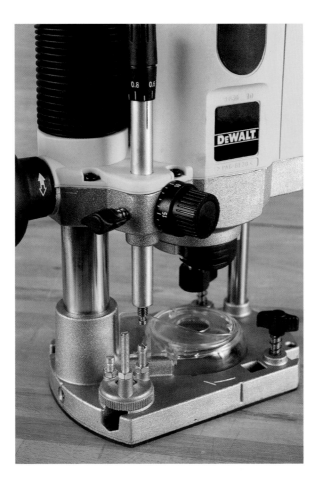

Introduction

THIS ISN'T BY any means the first book on the subject of routing, nor will it be the last. I am very conscious of the works that have gone before: indeed, I still have on my shelves an early edition of the pocket book written by Jim Phillips, the founder of Trend Machinery. There is, though, always more to be said that will add to everyone's fund of knowledge about this truly remarkable machine. Despite what some of the 'old school' may say about power tools, there really is nothing to touch the portable router for its domination of the woodworking scene today. I am sure that if cabinetmakers and designers of yesteryear had set eyes on this remarkable piece of equipment, they would have been both stunned and amazed, and I am sure, too, that they would have seized the potential - literally with both hands.

The router is no longer a tool for the professional alone. Today anyone can acquire a lightweight machine at a reasonable cost and put it to good use both in the home and in the workshop. That is what this book is all about: attempting to help the interested amateur through the confusions of choosing and using this fantastic machine. The various chapters will tell you everything you need to know, from making a purchase, through safety considerations, cutter types, hand-held operations, jigs and templates, table routing and joint-making (including dovetails with differing degrees of complexity) to what I hope is a series of genuinely useful workshop projects.

The router is no 'shop queen': far from it. As long as you are near a power supply and have a Workmate or similar work surface, you can produce good results quickly and easily. All that is required is common sense and a little knowledge – which is where *Routing : a Workshop Handbook* comes in.

With a router you can mould, joint and cut, not just wood, but also materials such as Corian, Perspex and aluminium. No other machine will allow you to tackle such a vast variety of tasks. If there is one machine you must own, apart from the obligatory power drill, this is it! There has never been such an exciting time as now to begin woodworking.

I hope you will enjoy reading and using this book as much as I have enjoyed writing it.

1

Meet the router

THE MULTIPURPOSE MACHINE

THE ROUTER IS a jack of all trades and a master of them all (see Fig 1.1). It can tackle the following tasks, and many more, with ease:

- creating tiny dolls' house mouldings (see Fig 1.2)
- making full-sized cornice and handrailing (see Fig 1.3)
- rebating, grooving and dovetailing (see Fig 1.4)
- mortise and tenon joints (see Fig 1.5)
- biscuit jointing (see Fig 1.6)
- tongue and grooving
- repetitive shape cutting with templates, e.g. for locks and hinges (see Fig 1.7)
- making bodies for electric guitars
- edge planing boards (see Fig 1.8)
- cutting kitchen postform worktop joints (see Fig 1.9)
- levelling the groundwork for relief carving (see Fig 1.10)
- precision-drilling hinge and shelf support holes (see Fig 1.11)
- producing raised and fielded panels and door frames (see Fig 1.12)
- carving a splat on the back of a reproduction chair or a name on a signboard (see Fig 1.13)
- machining inspection holes in chipboard flooring for electrics and plumbing
- trimming laminates (see Fig 1.14).

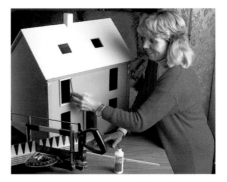

(Left) Fig 1.1 The once great name in routing – an ELU 177E 1850 watt ½in collet router, going full blast.

Fig 1.2 Applying mouldings to a dolls' house.

Fig 1.3 Fitting a cornice.

Fig 1.4 Sliding a back panel into a groove.

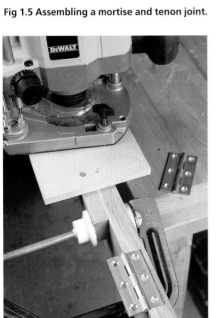

Fig 1.5 Assembling a mortise and tenon joint.

FIG 1.6 Biscuit joints in a carcass.

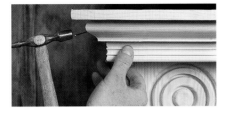

FIG 1.7 A hinge jig in use.

FIG 1.8 Using the router to plane the edge of a board.

FIG 1.9 An assembled kitchen worktop.

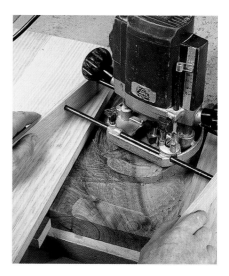

FIG 1.10 Machining the groundwork and face of a partly carved walnut 'rose boss'.

FIG 1.11 A bookcase carcass with holes drilled by a router.

FIG 1.12 A variety of solid panel doors.

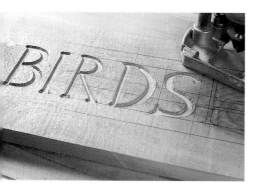

FIG 1.13 Freehand carving with the router.

FIG 1.14 A laminate trimmer in action.

A DEFINITION OF THE ROUTER

Occasionally you may come across an old-fashioned 'hand router' in a secondhand toolshop (Fig 1.15 shows one example). This bears little resemblance, apart from the name, to the subject of this book. It was used to fashion slots or 'housings' in wood, a job it did reasonably well for a long time. It may have been so-named because it creates a 'route' – a cut or slot – from one point to another. It shares this ability with the portable electric router, but that is about all they have in common.

The modern router is descended from fixed-head machines, still used by industry today although usually under computer control. However, once this machine grew legs (or plunge columns, to be more precise)

and walked, it became a wholly different animal in machining terms.

The router has a motor and switchgear, a base to keep it stable, handgrips to keep it under control and a means of pushing the cutter into the work (plunging). There is a plunge lock and a depth stop to give a precise depth of cut, and a fence for guiding the router cutter along the side of a workpiece. That, in essence, is all there is to the router.

WHAT MAKES THE ROUTER SO SPECIAL?

An ordinary mains-powered drill has a top speed of about 3500rpm (revolutions per minute). The router, on the other hand, has a top speed (depending on the size of the machine) of between 18,000rpm and

FIG 1.15 An old wooden hand router. The original owner's name is stamped on both ends.

FIG 1.16 A spindle moulder. Note the Shaw guards, machined table and a battery of switches for safe working.

24,000rpm – a considerable difference. But why this massive increase in speed? Quite simply, it achieves a higher level of efficiency. In fact, because router cutters have a small diameter, this equates well with the average spindle moulder running at only 6000rpm, but compensated by much bigger cutter blocks (between 10–15cm (4–6in) in diameter or even larger) (see Fig 1.16) and a considerable hike in kinetic energy.

The router has to achieve this tremendous power with much smaller, less efficient means at its disposal, and its solution is to drastically increase speed at the edge of the cutter, hence the high motor speed. At this kind of rpm the cutter will attack the work, slicing into the wood with an efficiency and smoothness that simply could not be managed at a much lower speed. At a lower speed the result would be very rough and ragged, and the machine would proceed at a very uneven feed rate, leaving a messy trail and severe burn marks where the cutter had passed over the wood. It would also cause the cutter to become overheated and dangerously damaged, and the motor would burn out quickly. Lastly, a slow machine couldn't manage anything like the size or depth of cut achievable with a high-speed motor.

**(Above) FIG 1.17
A fixed-base router:
an anglicized US
Black & Decker.**

**FIG 1.18 A plunge
router. This is where
it all started for the
author, with a MOF
96, now battered
and old, but still
going strong (the
router that is).**

FIG 1.19 An ELU MOF 177E router mounted under the Veritas table. The table has a lift-up top to make changing the cutter that bit easier.

It follows that anything that challenges the forces of nature so severely in terms of mass, momentum and friction also challenges the technology that creates it. Indeed, although the current crop of machines is pretty reliable, the history of the router is peppered with failed machines and cutters that just couldn't take the strain.

The lesson to learn from this is that such a dynamic piece of equipment needs to be harnessed so that it can be used safely and successfully.

HOW IT WORKS

Routers come in the following three basic types:

- fixed-base pattern, which is popular in the USA (see Fig 1.17)
- plunge body, which is very popular in Europe and the rest of the world (see Fig 1.18)
- either of the above two patterns used in fixed mode, overhead or inverted (see Fig 1.19).

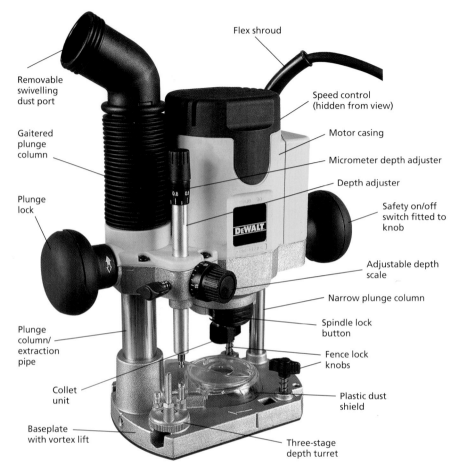

Flex shroud

Removable
swivelling
dust port

Speed control
(hidden from view)

Gaitered
plunge
column

Motor casing

Micrometer depth adjuster

Depth adjuster

Plunge
lock

Safety on/off
switch fitted to
knob

Adjustable depth
scale

Narrow plunge column

Spindle lock
button

Plunge
column/
extraction
pipe

Fence lock
knobs

Collet
unit

Plastic dust
shield

Baseplate
with vortex lift

Three-stage
depth turret

FIG 1.20 The DeWalt 621 super router.

To start with, we will concentrate on the plunge router, because this is the basic form.

THE PLUNGE ROUTER

The photo above shows the external features of a thoroughly modern DeWalt machine (see Fig 1.20).

The motor
Routers work at high speeds and the cutters are put under a lot of strain, so it's important

that the motor is well balanced. The weight of the motor core must be evenly distributed to give a smooth and reasonably quiet motor that will have a long service life. If this part of the exercise goes wrong, machine failure is guaranteed. Simpler motors have just a few windings, but the router has a multi-wound motor for even and continuous performance. The motor sits inside an outer series of windings, which create a magnetic effect opposite to those produced in the motor core's own windings: the result is very rapid

production of a high rotational speed. This quick build-up to running speed, coupled with the heavy forces applied to the cutter under load, means that special high-speed bearings are required. These are usually sealed to keep out dust and resin, which would soon gum up the ballraces and grind them down, thus creating loose, dry, overheated bearings. There is also a sealed long-life switch. Together, these are the items that make the thing 'go'.

Electronics

Nowadays, many routers also carry an electronics package which enables them to start gently rather than in a sudden, unnerving jump start which can pull a large router out of your hands. Another advantage of the electronics package is the matching of motor power to load, so the heavier the cut, the more power that courses through the motor. This explains the higher wattage of electronic models: they need more power for the electronics to work, but mainly to allow the motor to apply extra power so that it can operate at a constant speed, whatever the demands placed upon it. A choice of speeds allows the use of high speeds for small diameter cutters and low speeds for large cutters. Bearings and switches are common fail points, but these are replaceable provided that the fault is divined quickly enough (see

Chapters 2 and 3 for more on the subject of router repairs and maintenance).

Collets and cutters

The cutters are fitted to the lower end of the motor shaft via a collet. Collets differ from drill chucks in that the collet is a precision-milled split sleeve designed to hold cutters of just one shank size (see Fig 1.21), whereas a chuck has movable jaws to grip drills of different sizes. A chuck works well enough in a slow-speed drill, but for precision high-speed work the collet is the only practical solution (except for industrial cutters that are screwed directly on to the shaft). Normally a router will take different sized collets allowing a variety of cutters to be used. A retaining nut holds and clamps the collet tightly, thus gripping the cutter shank tightly. Special care must be taken with all collets to ensure that no damage results either to them or to the cutters (see Chapter 3: Router safety). A combination of spanner and shaft lock, or a tommy bar, provides the means to tighten or loosen the collet for inserting or removing cutters.

Plunging

Plunge-type routers have two very rigid, well-machined columns on which the body is mounted. To operate one of these you undo the plunge lock and push the body

FIG 1.21
1 ¼in insert
2 one-piece ½in
 nut and collet
3 ⅜in insert
4 ½in collet and nut
5 Lightweight ⅜in
 collet and nut
6 Lightweight ¼in
 collet and nut

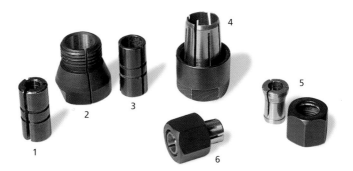

FIG 1.22 Two routers showing different plunge locks.

down, against spring pressure. Then you engage the lock once more at full-plunge depth (this depth depends on what setting you have made.) The plunge lock can consist of either a twisting handgrip or an entirely separate lever at the back of the machine (see Fig 1.22).

It is normal to machine in several passes so as not to strain either the motor or the cutter, so an adjustable depth stop and a three-stage revolving turret is fitted on most machines. This allows quick resetting between passes so that the final depth is reached in safe stages. The depth-setting rod can be a very simple one with nothing more than a lock knob to hold it, or it may be a more precise geared rise and fall type (see Fig 1.23).

FIG 1.23 A geared rise-and-fall depth rod and turret stop.

The base

The base is no less important than any other part of a router, because the motor must sit squarely upon it, without being at all unstable, and it must keep the cutter exactly perpendicular to the work surface. The hole in the base needs to be able to admit any size cutter within the designed capacity of that machine. The base is more than just a support, however. It will take guide bushes

for when you want to cut around templates. It also has holes for the supporting rods for the fence, and to take a roller guide and trammel bar for cutting circles (see Fig 1.24).

Dust extraction

The DeWalt 621 (see Fig 1.25) is unusual in that it is one of only a few routers that currently have built-in extraction for dust and chippings rather than the normal bolt-on facility. All extraction facilities tend to obscure the work and are inconvenient, but self preservation makes extraction with a machine as messy as the router an absolute necessity.

This describes the basic router. It does, however, come in a number of collet sizes, such as ¼in, ⅜in and ½in.

THE TECHNICAL DIFFERENCES

The light-weight router (¼in) comes as a budget-conscious version with about 400–600watts of motor power for amateur use. There's a heavier, professional type with 720watts minimum and, in the case of the DeWalt 'super router', a whopping 1100 watts of power. As the term suggests, the light-weight router is light, but it is quite well made. The collets that go with it tend to be simpler and smaller than those supplied with the professional models, and the kit comes with other bits and pieces so that you can get going straightaway.

The professional models have everything built on a much heavier scale: the collets are better made and come in a wider range of sizes. All of the attachments are larger and you have to buy them separately. These machines are designed for precision working: fine adjusters are available and a variety of guide bushes and a router table. These machines are capable of repetitive and quite punishing work in a professional environment (see Fig 1.26).

FIG 1.24 A Bosch 900ACE with guide bush, a trammel point, or bar, a straight fence, and a guide rail attachment.

FIG 1.25 A DeWalt 621 fitted with an extraction spout.

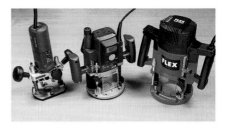

FIG 1.26 From left to right: a Bosch POF 500 A; a ¼in pro-model GOF 900 ACE; and a ½in Flex Porter-Cable model.

FIG 1.27 The base of the DeWalt 621, showing the vortex design.

Medium-duty routers

The medium-duty (³/₈in) models are now a bit rare. They cater for 'in between' cutter shank sizes and fall between two stools, being neither true lightweight machines nor heavy-duty ¹/₂in types. They do not often have electronic control, which seems perverse bearing in mind that ³/₈in cutters can be quite large. Some, like the Dewalt models, are heavily built, while the Makita amateur model is quite compact and comes in a neat little case. It has few accessories and tiny collets and, to be honest, this shank size of router is probably not of great interest to many people: I think that it's better to stay small or go for a large industrial router.

Heavy-duty routers

The ¹/₂in router has ceased to be just for the professionals. It is always very heavily built

and comes with a choice of collets or collet inserts (see Chapter 3 on cutter safety). A straight fence is standard, but all accessories are extras. Its sheer power and size mean that this class of machine will handle any task with ease.

Models with motor wattages of 1600–2000 are manufactured, though 1700–1850 is a typical rating. Electronics are essential for maintaining the right speed with any size cutter as these machines will work with both tiny and huge cutters. The best models are as accurate to use as a ¹/₄in router, but some can be a bit rough and ready in their adjustments.

Extraction systems

Extraction on routers is a contentious issue. It is a must, but manufacturers have really got to work a lot harder at finding convenient solutions. Virtually all machines, in all categories, can take an extraction pipe as an extra, but only the DeWalt 621, the Festo OF1010 EBQ and the Makita RP1110C currently have integral extraction. They have a 'vortex' lift system that draws the dust around inside the base and then swiftly up through a pipe which is in fact much fatter than the usual plunge column (see Fig 1.27). This results in maximum efficiency and no flexible hose hanging down to get in the way.

In this day and age there is no excuse for other machines not having this kind of built-in facility. I hope that when this book has to be revised for a future edition, this particular section will need to be changed substantially.

Specialist routers

There are other machines with a more minority interest. The laminate trimmer is quite a handy little machine (see Fig 1.28). It has quite a small 'footprint', tending to be taller than it is wide. You may wish to use a fence or roller guide with it, though it is

more usual to use bearing-guided cutters. Generally these will be bevel or chamfer cutters, though any small profile could be used if you are working on materials other than laminates. They usually have 500–600 watts of power, which is quite a lot. For many purposes this machine could prove very handy as an alternative to a professional ¼in router.

There are several machines on the market designed for tasks such as cleaning putty from glazing rebates or for machining aluminium sections. They are made with double-glazing manfacturers in mind and are not really of interest outside their target market.

The fixed-base router

Last, but not least, it is worth paying homage to the fixed-base router, a product of the USA. These have all but disappeared from the UK and the rest of Europe, but many years ago, before the almost meteoric rise of the plunge router, you could buy one in the UK. They are still sold in the USA, where they have some devotees, and no doubt some woodworkers in the UK persist in using them as well (see Fig 1.29).

There are definite merits to this machine, which neatly combines depth of cut adjustment with the actual height setting. No swift plunging action here – you lower the router into the work carefully. Plunging is itself not perfect, because the plunge action is not always silky smooth and can result in a slight divot where the plunge is first made.

It has to be admitted that the fixed-base router, with its wide overall base size and the lack of 'bounceback', is in some ways more predictable. This type of machine certainly isn't about to make a comeback, however, so unless you happen to be offered one of them second-hand, it doesn't really come into the buying equation.

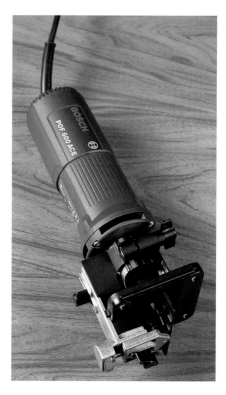

FIG 1.28 A Bosch POF 600 ACE fitted with a laminate trimmer base.

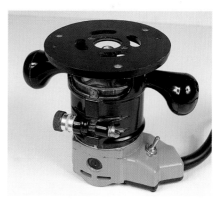

FIG 1.29 A fixed-base router inverted to show the guide bush socket and the depth-wind mechanism.

FIG 1.30 A router at rest.

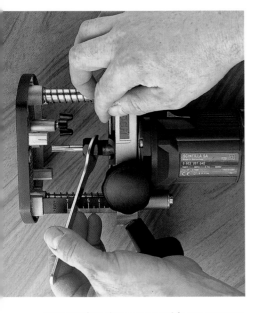

FIG 1.31 Changing a cutter with one spanner and a tommy bar.

GETTING STARTED

1 When you first take your new router out of the box, do read the manufacturer's instructions and understand them – it might make a significant difference. Ensure that there are no loose parts, especially any that might have got lodged in the machine itself and pose a hazard when it is switched on.

The machine I'm using here is the Bosch POF 600 ACE. Other routers have the depth stop, scale and turret at the front. The Bosch has no turret: the front scale is fixed and the depth stop is at the rear.

Figure 1.30 shows the router at rest. The motor, and therefore any cutter that might be fitted, are well clear of the workpiece.

2 Make sure that your router is unplugged and then lay it down so that you can fit the cutter. A few models have a flat-topped motor housing and can be rested on this.

With the machine I'm using the cutter is fitted using a spanner and a tommy bar (see Fig 1.31). This is the preferred method, because it doesn't require a great deal of effort, and there is less chance of skinning one's knuckles on the base of the router if only one spanner is required. Do not overtighten the collet nut. Select a small, two-flute, straight cutter for this experimental cut.

3 Set the electronic speed control (if there is one) to match the cutter you have just fitted. If this is left until later, you may forget and start cutting without having made the adjustment. In general terms, a small cutter should be run faster than a large cutter, so in this particular case top speed will be fine (see Fig 1.32). (Chapters 3 and 4 give more information on selecting cutting speeds.)

4 With the power still off, gently plunge the stationary cutter until it just touches

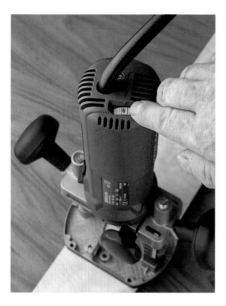

FIG 1.32 Setting the correct speed for the chosen cutter.

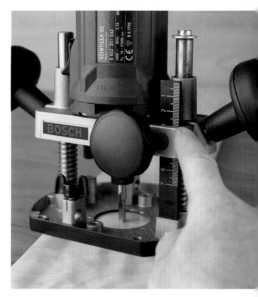

FIG 1.33 With the cutter touching the work, check the scale for your starting depth.

the workpiece. Then push the plunge lock lever to the 'on' position: the motor head then stays in this position.

5 Decide how deep you will need to plunge (in this case it will be the diameter of the cutter shank: about 6–7mm ($^7/_{32}$–$^9/_{32}$in) per pass is safe) (see Fig 1.33). Now turn the router round and wind the depth rod up or down until the gap between it and the stop on the base is about 6–7mm ($^7/_{32}$–$^9/_{32}$in) (see Fig 1.34). You can check this measurement by using a ruler or even a metric drill bit with a shank of the right diameter.

If you want to make a deeper cut in two passes, the two milled nuts on the rod can be turned to set an upper and lower limit. Then, after the first pass, press the sprung button and push the rod up to the top setting, ready for the second pass. This doesn't allow for a situation where, for instance, very deep

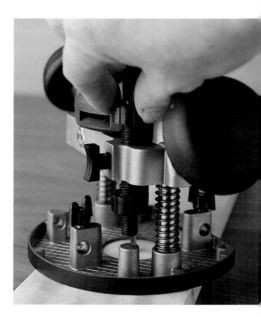

FIG 1.34 Setting the depth stop at the rear of the machine.

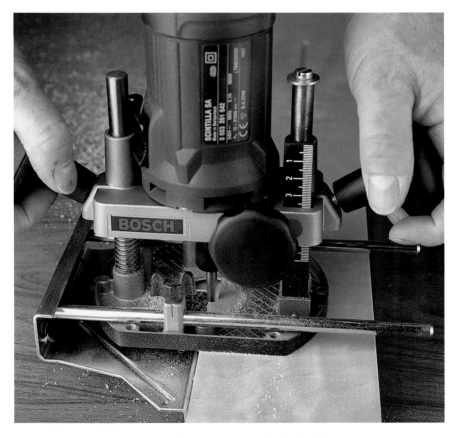

FIG 1.35 Making the cut. For clarity, the operator is standing behind the router.

cutting is being done with a ¹/₂in shank cutter on a large router. In this case, professionals often do each pass, setting the depth by eye, using the turret setting for just the last pass only.

If you are new to routing this is not recommended. You need to get the hang of machining safely, and not all cutter and machine combinations behave in the same way. (see Chapter 3 on Router safety for more information.)

6 Fit the router side fence and lock it in place with the knobs on the base.

7 The intended test workpiece must, without fail, be clamped down for safety. Failure to do this will end in disaster – a minor one maybe, but a disaster nonetheless.

8 Before starting a cut, it is vital to recognize which direction you should be cutting in. When machining an edge rather than the centre of a workpiece, the direction that the cutter is fed into the work should be against the rotation of the cutter (see Fig 1.35). Most routers have an arrow marked on the base to make this

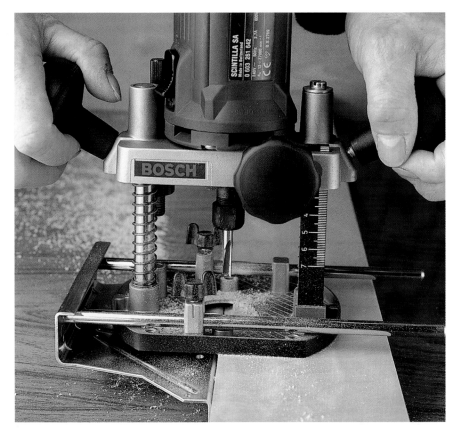

FIG 1.36 Releasing the plunge lock.

obvious. If a cut is made in the wrong direction, this is known as 'back-feeding' and can result in a rather spectacular 'jump' as the machine is pulled by the cutter along the workpiece.

It does this because the cutter acts like a wheel on a car pulling the vehicle along. In this instance there are sharp blades instead of wheels. The results may not be very serious most of the time, but it is better to play safe and avoid this happening. Cutting in the correct direction means the sharp edge of the cutter is being fed into the workpiece.

9 Hold the router in position on the workpiece with the fence against the edge. With the turret adjusted to the highest stage for the first cut, switch on, plunge, lock and pull the router towards you, taking care to keep the fence against the workpiece. Stop cutting after a few inches, release the plunge lock so the cutter can spring back out of the work, and switch off (see Fig 1.36). That is your first cut – very easy to do. However, the whole subject is much bigger than that. The succeeding chapters will show you the many virtues of this effortlessly versatile machine.

2

Choosing a router

ON THE MARKET today there is a profusion of routers from virtually every power tool manufacturer in the world. This chapter sets out to help you through the fog of confusion which can surround difficult purchasing decisions.

WHAT TO LOOK FOR

There are always awkward choices to be made when we have to buy anything new. Money is often the deciding factor, although on examination of my past buying habits I realize thankfully that, in the end, considerations of quality, reliability and extendability played a large part. I've also learnt from experience that you do get what you pay for. A cheap piece of equipment cannot realistically be expected to match the performance of an expensive one, or even to keep on working – there are exceptions, but not many.

So we should bear this in mind when looking for a router. Making a list of your requirements will help, because it narrows the field considerably. Then there are tests in woodworking magazines and the opinions and experiences of fellow woodworkers, not to mention the occasional chance of a 'hands on' test. Unfortunately, finding and

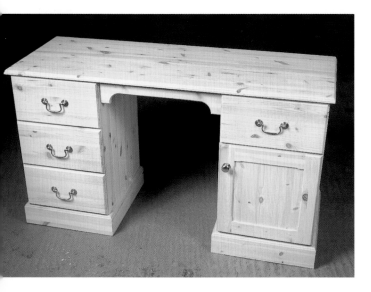

FIG 2.1 A home project. This attractive pine desk is formed from two cupboards which could also be bedside cabinets. The whole thing, with a mirror added, becomes a dressing table and is much easier to make than it looks.

interpreting all this data is difficult, which is where this book comes in. Bearing in mind that it is intended for those with at most limited experience of routing, the following section tends to cover those machines which are readily available rather than esoteric or strictly trade-only models.

MATCHING THE TOOL TO THE INTENDED REQUIREMENTS

Router size and power

Ask yourself honestly: what do I expect to do with this machine? If your aim is to do a few jobs about the house and create some simple pieces of furniture (see Fig 2.1), then you don't need a super-duper German ½in router, however good it looks in the advert. Likewise, if you want to tackle very heavy work, perhaps some joinery such as window sashes or handrailing (see Fig 2.2), then a small, lightweight router is pretty useless.

So, consider the tasks you have in mind. If this is your first router, it would probably be best to purchase a ¼in model rather than a large one. It will be cheaper, the cutters will be smaller and therefore cheaper, too, and it won't be a monster to use.

In fact, a large percentage of machining can be undertaken with a ¼in router quite successfully if you use a little ingenuity. Power isn't lacking these days, although multiple passes will be needed to prevent breaking the narrow-shanked cutters.

System extendability

I have already touched on the router size and power. In the end, only you know what work you expect to undertake, although once you get to know the machine better, other ways of using it become apparent, and you will find yourself drawn towards larger projects that would benefit from a much bigger machine. Planning ahead might entail buying a small

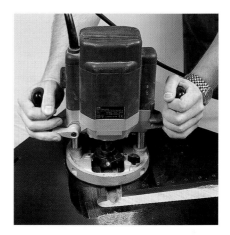

FIG 2.2 A good example of professional joinery: machining the dovetailed housings in a 'string' (the side into which the stairs fit) using a special staircase jig.

FIG 2.3 The Bosch router 'system', showing the GOF 900 ACE. Larger Bosch models use the same accessories.

router now, with the possibility of acquiring a bigger one later on. System extendability plays a part here, because a ¼in router bought from firm 'X' might have components that will work with their own ½in model, but not with the ½in machine from firm 'Y' (see Fig 2.3).

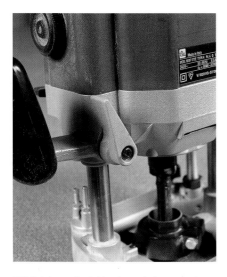

FIG 2.4 A comfortably shaped plunge lock lever.

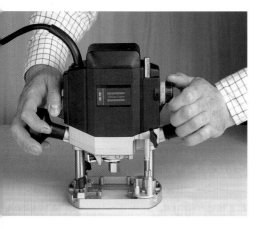

FIG 2.5 An ergonomic router. All the controls are 'to hand'.

Ergonomics and general handling

Ergonomics are important. It is easy to go for the look of a particular router and then find it has uncomfortable handles and knobs or fiddly controls, such as a speed-setting wheel that is recessed too far into the case

and is hard to turn. Some Japanese routers have stamped-steel plunge levers which some people find unpleasant to operate, especially when they are used to the European models (see Fig 2.4). Half-inch routers are not only big in themselves, but sometimes have very large handgrips and controls that are stiff or uncomfortable.

When you pick up a router and put it into action it should feel natural, with all controls and switches pretty much to hand and pleasant to operate (see Fig 2.5). Actions such as plunging should be very smooth and efficient. Things aren't always like this, so try several different models before forming an opinion of what suits you. Incidentally, plunge columns sometimes need a little lubrication before they will work perfectly. Another operational annoyance can be a mains lead that is too short – not the end of the world, but do you really want to go to the effort of changing a lead just because a manufacturer was too mean to fit a longer one?

Kits and cases

The lightweight routers are often sold in kit form, though without a case. The reason is that the extra parts are stamped metal and plastic with some standard nuts and bolts. This makes it economical for the manufacturer to provide the whole thing in one cardboard box and call it a kit.

The cheaper, less-specified professional models (those without electronics and with a lower motor rating) normally come only with a fence, a dustspout and a guide bush. This keeps the overall cost down. The top-end models, which have electronics and bigger motors, will often come in heavy-duty steel cases along with some extras, because these fit in neatly with the manufacturers' pricing policy.

It might seem that the second option is not such good value, because it comes

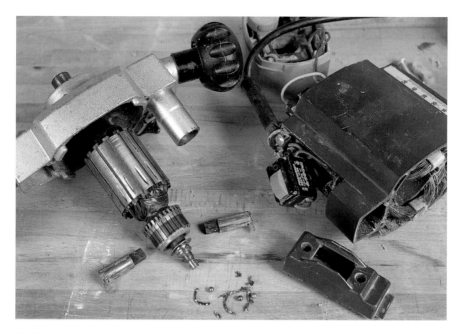

FIG 2.6 A router with a completely wrecked top bearing. Note the switch and brushes (the main bottom bearing is hidden from view). Note also the grooves on the motor – these balance it.

without extra bits and pieces. However, it may be the right one. You should also consider the price and whether it has a system to back it up. What kind of guide rails, guide bushes and tables will go with it? Top-end models are built to a heavier standard and have more power than the cheaper models because they are aimed at the professionals, even if amateurs make up a large part of the 'purchasing group'. Take a good look at what rival manufacturers have to offer before making a final decision.

Price versus quality

Price will depend on how much you are being sold: a small or large motor, a product for professionals or amateurs, and whether it's in kit form or not. There is also the dealer's mark-up to consider, because different dealers will have different arrangements with the manufacturers depending on how many units (or routers) they expect to sell.

When shopping around, you will probably find your local professional shop is a bit pricey. Often they are selling to trade customers at prices exclusive of VAT, because these customers can reclaim the VAT. The result is that the price sounds reasonable until you add the VAT figure. In fairness, one must say that in the course of a year they won't perhaps sell anywhere near as many units as a nationally advertised mail-order outfit, who will normally be selling inclusive of VAT, but whose margins can be trimmed to match their larger turnover. DIY superstores sell the cheaper amateur models, and it is as well to check between stores to see if prices vary or if there is a special price offer.

Reliability

We all want something that won't go wrong or give us any trouble. In practice there is no such guarantee, except the manufacturer's own.

Price does play a part in determining how reliable something will be, but by and large all routers today are pretty good. Listen to the opinions of other woodworkers, because they may already have valuable experience with different routers. As long as a machine is used for the kind of work it was intended for, there shouldn't be too much to worry about. Regular servicing and prompt repair of worn or damaged parts will do a lot to extend the life of your router (see Fig 2.6 and Chapter 3).

Availability of servicing and spares

Generally speaking, most manufacturers who supply the UK market have put in place proper 'spares and repairs' facilities. If you are in doubt before purchasing, check with the dealer how well they think they can cope with any repairs or servicing which you may need.

Most powertools come with an 'exploded' parts diagram. This is important and should be kept safely with the warranty, so that if a 'user fit' item does go wrong you can readily identify it. Dealers and service centres need to locate the item on the stock computer, so the exact description and part number are needed. They also need the serial number of the machine. Professionals are often able to have repair work done at short notice. This is only fair, because they need their tools to earn a living and fulfil work obligations: the rest of us just have to wait a little longer.

Warranties

UK consumer law has to be observed by all powertool manufacturers and dealers. All tools come with a warranty card which gives details of the warranty terms and conditions, as well as details of where to send the tool in the event of failure.

Normally, amateur equipment is guaranteed for one year. Professional tools are sometimes only covered for six months, because of the wear and damage that they can suffer. There are exceptions to this: some brands have extended warranties and special servicing arrangements that can be particularly attractive to the prospective purchaser. As always, it pays to check what terms are on offer with each tool.

Some professionals do certain repairs themselves, such as changing the switch and bearings. This is not something to be undertaken lightly and should not be attempted by anyone without the relevant knowledge and experience. It can be dangerous to both operator and machine (see Chapter 3).

Shown here is a selection of routers, mostly $\frac{1}{4}$in, but with some $\frac{1}{2}$in models. They represent just part of what is actually being manufactured today in a field which is constantly changing (see Figs 2.7a–l).

FIG 2.7a This cheap Router Devil is remarkable for the money.

FIG 2.7b This Freud has 1000 watts of power, but a rather large base.

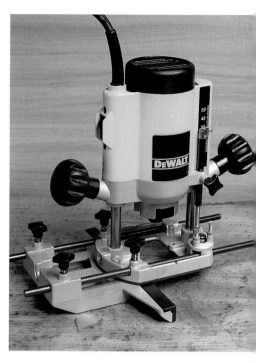

FIG 2.7c The powerful 800-watt starter model in the DeWalt professional range.

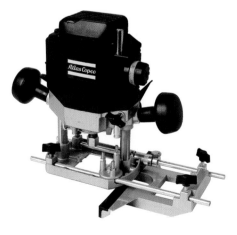

FIG 2.7d The Atlas Copco 1000 OFSE, a good professional machine.

FIG 2.7e This Bosch 900 ACE is part of an impressive line-up.

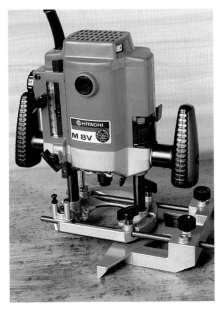

FIG 2.7f A newish Ryobi machines with bulbous, but ergonomic, handgrips and 'gaitered' plunge columns.

FIG 2.7g The Japanese build a lot of routers. This M8V by Hitachi is the electronic variant of the single-speed M8.

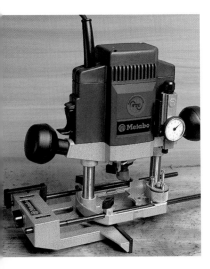

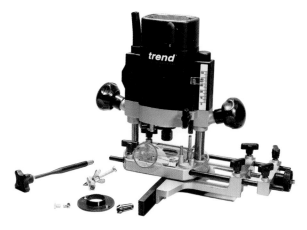

FIG 2.7h Strictly for the professionals, this Metabo has an unusual dial-type depth gauge.

FIG 2.7i Trend's own bid for a share of the professional market, the T5.

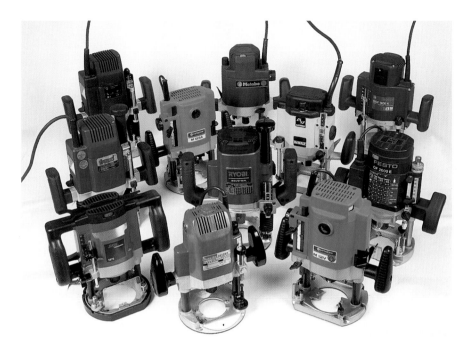

FIG 2.7j Just some of the ½in machines currently available.

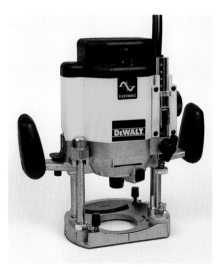

FIG 2.7k The industry standard DW625E machine, a reincarnation of the ELU177E.

FIG 2.7l The affordable and incredibly powerful Freud FT 2000VCE. It is ideal for mounting in a table and has an in-built fine-depth adjuster.

3

Router Safety

LEARNING FROM THE MISTAKES OF OTHERS

ON MY BOOKSHELVES, along with all the other titles related to woodworking, is a splendid volume by Nigel S. Voisey called Woodworking Machine Safety. It sounds boring: just a series of strictures - don't do this, don't do that. In fact, it has a much more positive approach. It tells the reader the correct way to use such woodworking machinery as a bandsaw, a planer or a circular saw in order to avoid those hideous mistakes

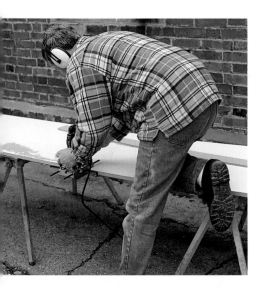

FIG 3.1 The versatility of the router: using collapsible sawhorses out of doors.

which, if our luck isn't in, could land any of us in casualty.

We all tend to take safety for granted. I have certainly had to eat my words before, describing this or that router as 'relatively safe' and shortly afterwards meeting more than one person (in one instance a well-known and respected professional) who has come to grief with that very machine.

My experiences, and those of other router craftsmen, show that they are pretty safe, but that remains so only if care and common sense keep things that way. This chapter should help to point out the most obvious problems, as well as some of the unexpected ones. Anything directly relating to safety is to be found here, while safety-related issues, such as working freehand or using a router in a table, are dealt with in the relevant chapters. There are specialist publications which deal with safety issues, but keep this book handy at all times and make this the most well-thumbed chapter of the lot.

WORKING AWAY FROM THE WORKSHOP

The router, like any other powertool, doesn't need to be confined to the workshop. It's easy to forget with a versatile, yet relatively lightweight, tool like this that it is possible to take the tool to the work. You can easily work out of doors, in the garden or on a patio or area of hard standing (see Fig 3.1). You can also work indoors, of course, perhaps in

FIG 3.2 The author trying to 'DIY' amid domestic chaos.

FIG 3.3 Different ways of supporting work: in front, a Four-Legged Friend; behind, the ubiquitous Black & Decker Workmate and part of the author's own board-cutting set-up (see Chapter 14).

a room where other building or decoration work is taking place (see Fig 3.2). More controlled environments, such as garages and sheds, I shall come to later.

In the garden

Gardens often aren't level, so find an area that is. Concrete or paving is best, and it is easier to sweep up afterwards. If yours is a household of children and animals, then ensure that they are kept well away from the working area, because both can show an inquisitiveness bordering on the dangerous. In fact, my own experience is that it's best if they are somewhere else entirely. Once a mistake happens it can snowball, and it may

FIG 3.4 Working in the garden using extraction. Here, the router is being used to clean out putty from glazing rebates.

to errors of judgement which further affect safety. Professionals may work in noisy, dusty workshops, but they don't suffer the interference of outsiders, of any age or species.

The weather is always a concern when working out of doors. Rain and electricity don't mix, so don't be tempted to finish that last cut as the rain begins to fall: it isn't safe, and neither are puddles on the ground where extension cables are lying.

Supporting the work

Good work support is essential. Small work will clamp adequately on to a Workmate or similar appliance, but long workpieces or 2440 x 1220mm (8 x 4ft) boards need two sawhorses or the ready-made metal equivalents, made of collapsible tubular steel, which perform a similar job (see Fig 3.3).

Clearing up

Even though you may work out of doors, it is still worth having dust extraction. The mess goes everywhere and can be difficult to sweep up (see Fig 3.4). This subject is covered fully in the section on router safety.

Noise

Noise pollution is now very much recognized by the authorities, but sometimes the person making it is the last to hear it. It helps if your neighbours show some tolerance towards the work you are trying to do, but we don't all get on with those around us and the result can be that almost any activity can provoke a negative response. Choosing your moments can help. First thing on a Sunday morning is not thoughtful. Likewise, late at night is not

good either, even though many of us have to do this work outside normal hours. Do by all means ask neighbours if the noise you're making is acceptable, but bear in mind that those who are not making a fuss might just be giving a polite response when in fact you are disturbing their peace.

WORKSHOP SAFETY

A garage or shed is an excellent place in which to carry out woodworking operations. Many of us have one or the other, although they may not be in an appropriate state for immediate use. If you have a proper workshop already so much the better, but for many this isn't an option and the need may be an occasional one anyway. What are the basic requirements?

Repairing the structure
For a start, the building needs to be safe and sound. If it has a leaky roof or is in danger of collapse, the first project might be complete renewal. If matters are not so bad, carrying out any repairs will ensure that the building has plenty of life left in it.

Light
You need good illumination. Daylight is ideal but it should be backed up by artificial light of an adequate level, possibly a mixture of bulbs and fluorescents, because strip lights can be uncomfortable on the eyes and cause headaches (see Fig 3.5).

Power supply
Obviously you need a power supply. An extension lead might do, but a better solution by far is to install a supply from the house. Consult an electrician about the best way to do this. The choice is between an ordinary cable strung from a tensioned catenary wire between buildings using posts to carry it, or an armoured cable laid underground at the specified depth (usually about 76cm (2ft 6in

minimum) (see Fig 3.6). Your electrician will no doubt be very happy for you to dig the trench, but in the UK it is illegal for anyone to connect new works unless qualified to do so.

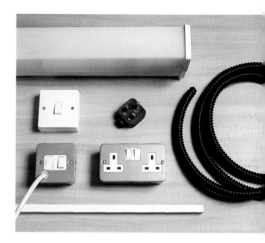

FIG 3.5 Lighting and power fixings. From top to bottom and left to right: an enclosed strip light, a light switch, a rubber plug, flexible conduit, a fused spur unit, a metal clad socket, and rigid plastic conduit.

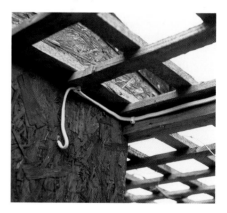

FIG 3.6 A third way of getting power into the workshop: using an existing solid structure, such as a trellis, to carry the cable. Note the drip loop which prevents water being carried into the shed.

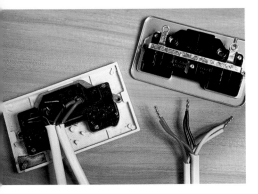

FIG 3.7 The left-hand socket has problems: unbushed wires (allowing one wire to slip out), bare earth wires and insulation that has been cut through, which will lead to shorting and possible fire. On the right are properly bushed wires, and a sleeved earth, ready to be fitted to the socket.

FIG 3.8 An RCD circuit breaker double socket, which is easy to fit. Larger RCDs can protect an entire installation.

Electrical work

Any electrician who makes that final connection must be qualified to check and certify the whole of the new installation, for which they will make a charge. DIY shops sell a lot of electrical materials, such as cables and sockets, but DIY installers shouldn't really tackle the work unless they are very experienced (see Fig 3.7).

Circuit breakers

One important thing to have is an earth-leakage circuit breaker protecting the entire installation. This may be fitted in the house rather than the workshop (see Fig 3.8). It means that in an extreme event, such as a circuit fault, lightning strike or flood, the circuit is switched off and made safe.

Making space

It is better to work in a building rather than in the open, because it usually contains the noise and you can work despite the weather. The downside of being inside is that your working area needs to be large enough and

FIG 3.9 'A place for everything and everything in its place.'

tidy enough to make it practical: a good clearout may be necessary. You should aim to create a main area for day-to-day activity while using more obscure areas for shelving and cupboards (see Fig 3.9).

Storing volatile substances

Do not get into the habit of storing cans of petrol or other volatile substances in your workshop. With switches or other electrical apparatus there is a genuine risk of a spark causing ignition if vapour is in the air.

Purpose-built workshops

Of course, if you have the space and the money you should consider a purpose-built workshop (see Fig 3.10). Various types are available, but you should be aware of what planning permission may be required.

Heating

Care should always be taken with heating any workshop. Electric heaters may overload the circuit, and woodburners or even space heaters may pose an unacceptable hazard, so think carefully about your own particular situation and get a bit of advice from friends or professionals. Gas heaters are all right as long as they are far enough away from dust and combustible materials. A safe alternative is a ceramic heater, available from tool and hardware suppliers.

Power outlets

If your workshop is an existing building it may be worth fitting more power outlets in useful places. Consider using metal-clad sockets, because they are better protected from damage.

The workbench

A workbench of some sort is needed, but it doesn't need to be large. In the age of the powertool, it is more useful to have a solid worksurface away from the walls and at a

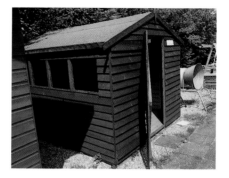

FIG 3.10 Full-length windows, and plenty of width and length, make this shed a good choice for a workshop.

lower height than a traditional workbench (see Fig 3.11). This is more suitable for machining operations, whereas a bench needs to be high enough, and fitted with a vice, to make handwork possible.

The timber, board and numerous jigs that can proliferate when you work with a router also need to be stored, but this isn't always possible, so consider buying sheet materials only as you need them.

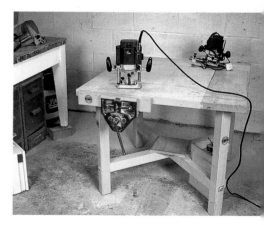

FIG 3.11 A student's bench, lower than the usual woodworking bench and, with its square top, ideal for work with a router.

FIG 3.12 Sensible clothing, including a monkey mask, eye and ear defenders.

Personal safety

It's human nature to go at a job without getting properly kitted up. We all do it, even - perhaps especially - the professionals.

There are a variety of risks to the router operator: noise, dust, chippings, loose cutters and actual broken pieces of cutter material, not to mention accidental abrasion of electrical flex.

All powertools come with a sheet of do's and don'ts, and they are actually worth reading. Some of these personal warnings are a matter of common sense and simply entail changing the way we approach practical work. Keeping an electrical lead out of harm's way will remove one important risk, and unplugging the router before changing the cutter helps you to avoid another. Other safety requirements do entail spending some money and making choices in the process.

Let's start with the feet. All wood-working should be done with adequate footwear. Probably, the greatest risk when routing is dropping the machine on your foot, either running or switched off – one will make you scream, the other will make you howl! Workshoes or boots with reinforcement are best.

Next is the apron, smock, boiler suit or warehouse coat. You don't have to use proper workwear, but you can at least take it off when you leave the workshop, and it keeps you free from the risk of getting looser clothing caught in the machine. Capacious pockets can be useless, because they can fill with chippings quite quickly. Sleeves should be close-fitting or properly rolled up (see Fig 3.12).

People frequently ignore the need for ear defence. Ear defenders or ear plugs are an inconvenience, but they play a vital part in saving your hearing. Routers have a particularly high-pitched scream, especially when being worked heavily, and continuous exposure to this level of sound can result in loss of hearing at some frequencies and a tendency to acquire tinnitus. The trouble is that ear damage is apparent only after it has already occurred, by which time it is too late – so protect yourself.

Some people find that earplugs drive dirt and wax back into the ear, so defenders can be better because they don't interfere with the workings of the ear. If you use a powered respirator helmet as well, it is necessary to ensure that its headband doesn't touch that of the ear defenders. This can result in an uncomfortable sound vibration, which is transmitted from the respirator to your ears, undermining the point of wearing the ear defenders in the first place.

Your eyes are the most immediate safety priority when machining. Being hit in the face by chips of wood or carbide is rare, but unfortunately it can happen. Safety spectacles with sideshields or ventilated goggles are all right, but a bit of a nuisance to

wear. Also available are the kind of flip-up faceshields used by turners and they work quite well because they sit away from the face. All too often this kind of protection is ignored because it is inconvenient.

It is very important to wear a dustmask or air-fed respirator to protect yourself from dust. The smaller the particles the more dangerous this dust is. This applies whether it is wood, coal, asbestos or grain dust – it is all very dangerous. Any kind of protection will help although, to be honest, ordinary dustmasks are less than wholly effective and do not last long (just a couple of hours before they need replacing).

Much superior by far in terms of lung and

eye protection are the lightweight air-fed helmets from Racal, Record Power and Trend. These give clean filtered air and proper impact protection for between roughly £130 and £190. The filters last long enough to make them more economical overall, and they are much safer than any other method. A small rechargeable battery ensures adequate working time, and replaceable visor overlays ensure clear vision. I cannot recommend this kind of protection highly enough: it should be the standard for any woodworker (see Fig 3.13).

The subject of fingers and hands and looking after them is covered in the next section on router safety, and in Chapter 7.

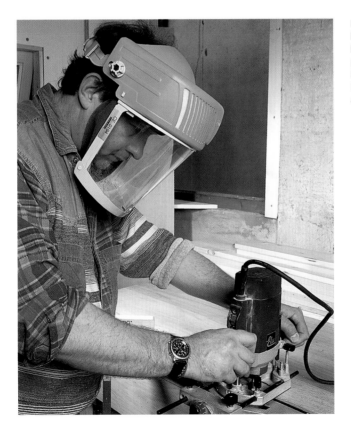

FIG 3.13 The Pureair helmet being used by Alan Goodsell, past editor of The Router magazine. Note the face seal around the edge.

ROUTER SAFETY

If you have spent good money on a new router, you will treat it as your pride and joy and, being new, it should respond in kind. Everything ages and gets worn or damaged, yet most powertools will stagger on almost indefinitely, especially when given some care and maintenance.

Cutter abuse

Routers are intended for quite heavy and punishing work, but they fare a lot better if used for the level of work for which they were intended. If you attempt heavy, single pass cuts with a lightweight model of around 600watts or less the strain will show after a while, even if it manages to see out the warranty period. The cutters won't like the abuse either, and neither will you. In fact you, the operator, are the best judge of how the machine is faring. If it is always under apparent strain and cannot cut quickly and efficiently and without some nasty accompanying noises, there's something wrong. The question is what?

If you suspect that a new machine is going wrong, contact the dealer who sold it to you. At the very least, he may be able to tell you if you're doing something incorrectly, but equally he must get the machine repaired or replaced if it is at fault. I was once sold a very large, well-known brand of router only to discover that it ran at half speed and produced a long and pretty trail of bright blue arcing running around the commutator – where, in fact, the fault turned out to lie.

Other possible faults on new routers might involve switches, electronics or bearings. These might have escaped factory inspection, but could show up after some use. Should a problem develop you'll find that it will usually be one of these typical long-term wear items.

Switch faults

The router's on/off switch is very vulnerable to getting packed with dust and resin, especially from MDF (medium density fibreboard). The switch blade contacts have a tendency to wear, and with repeated usage will gradually burn away or stick together. My old ELU MOF96 (which I still use) once developed an unreliable switch. It used to come alive when the switch was off and vice versa, and eventually it stayed on permanently. This breakdown occurred over days rather than weeks and was quickly dealt with, though it's not something you should tackle yourself unless you have the necessary competence. When I smashed open the old sealed switch unit with a hammer it revealed a set of switch blades tightly packed with MDF dust and severely burnt and shortened by thousands of operation cycles.

Faults in the electronics

The electronics control package for correct speed control can give out very suddenly, and after several hurried changes of fuse it becomes obvious that a visit to the repair shop is unavoidable. Motor brushes do eventually wear out, and this wear can

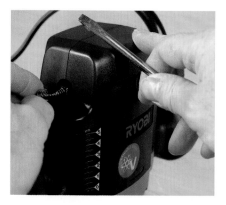

FIG 3.14 Half-way through changing the motor brushes.

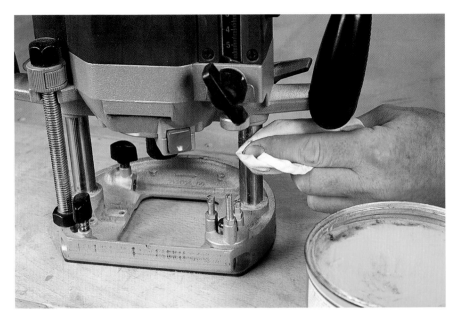

FIG 3.15 Waxing the plunge columns.

normally be observed by removing the case or brush covers. If changing them is easy according to the manual, then there is no reason why you shouldn't do it. Some machines, however, have an intricate arrangement for locating them, and it is safer to pass this job on to an expert. An electrician can do it, but the correct brush parts must be fitted (see Fig 3.14).

The answer is to have your machine regularly serviced and, when the switch misbehaves, fit a replacement quickly. Then at least you don't have to worry about the motor suddenly turning on when you thought it was off.

Replacing bearings

Routers have two bearings on the motor shaft. There is normally a large, heavy-duty one at the business end and a smaller one at the top: the smaller one is under less strain than the one directly above the cutter. These bearings are normally sealed and are a special high-speed type, so if they need replacing it is essential that the same type is fitted. This should be done by an experienced person: it's a tricky job removing and returning the motor shaft and all the other parts that get in the way, undamaged and in the right order.

Lubricating plunge columns

It is necessary to lubricate the plunge columns in some way and to avoid losing the sliding depth stop which is needed for setting the plunge depth against the turret stop. Some depth stops can fall out quite easily and the newer, geared pattern are much to be desired. I find that a machine wax, i.e. not a water-based one, is good on columns (see Fig 3.15). Oil tends to attract dust. Lubricated columns allow you to plunge easily and avoid aggressive contact with the workpiece when forcing it down too hard. Silicone spray lubricant also works, but

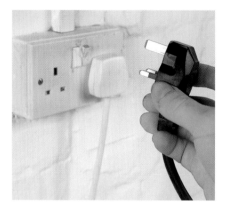

FIG 3.16 Unplugging the router.

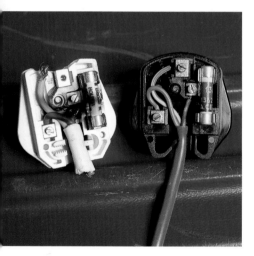

FIG 3.17 The plug on the left shows typical faults: broken Bakelite (allowing the earth pin to waggle and become exposed), a missing screw, and no cable restraint (causing the live wire copper filaments to tear and melt under load). The plug on the right is correctly wired.

don't let it get on your workpiece, because it can repel any finish you might apply later.

Safe working with the router table is covered in Chapter 10, but you should stick to the manufacturer's recommendations as to whether a cutter should be used freehand or in a table. Don't chance it: they mean what they say.

Making the machine safe

Some people seem to have difficulty with the idea of switching the router off before changing the cutter. We've all done it at some time or other, but it's nothing to be proud of. With 18,000–24,000rpm and up to 2000watts of power, a router is a dangerous animal. So get into the habit of switching off and unplugging. If you unplug, your safety is guaranteed: switching off alone is not enough (see Fig 3.16). The mention I made in the last section about worn switches should be enough to convince any powertool user.

SAFETY CHECKS

The plug

Before starting work there are certain things worth checking for your safety. If a plug is broken or wires are loose, deal with them straightaway. Fortunately, most new machines come with moulded-on euro plugs. If one of these plugs does need replacing, cut the flex close to the plug with wire cutters and dispose of the old plug carefully, because it can still be plugged in and has exposed wires that could be lethal (you should remove the wires from a conventional plug completely). Always fit modern plugs with half-sleeved pins (these are the legal requirement). Preferably, these plugs should be of the unbreakable rubber sort. Make sure that you fit a fuse applicable to the load (see Fig 3.17).

These legal requirements or regulations that I mention from time to time really are important. If the equipment wasn't up to scratch and an incident occurred, especially if it involved someone else, insurance claims, criminal proceedings or private prosecution might result.

The lead

The lead should be in good condition, too. Abrasions or cuts can happen quite easily. Never use the lead as a means of picking up the tool: you might not pull the cable out of the cable grip on the machine, but you might snap the copper cores, causing an intermittent on-off effect which is interesting, but dangerous. Replace a faulty lead immediately. Re-use the rubber protector fitted at the machine end of the lead, because it reduces the stress on the lead. You could take the opportunity to fit a longer lead if the original is rather short: anywhere between 2.5 and 4 metres (8 and 13 feet) is acceptable.

Chippings

If the router has been used for inverted machining, check that the casing is free of chippings: it can get packed with them while operating upside-down (see Fig 3.18). The result can be flying debris or a machine that jams when you start it up but, worst of all, the motor windings can get abraded, and this may cause the motor to burn out, possibly in spectacular fashion.

Fence lock knobs

Ensure that fence lock knobs have anti-vibration springs so that they don't work loose while machining without a fence in place. If there are no springs, remove the knobs, otherwise one at least could come out and strike the cutter. It has happened to me, though fortunately it resulted in nothing worse than a partly mangled knob.

Dust extraction

Fit extraction wherever possible and ensure that it is working. You can machine away quite merrily without realizing that the chippings are not being drawn up. This is worse than not fitting extraction at all, because it all starts to get jammed, with

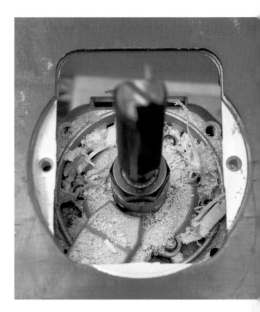

FIG 3.18 An inverted router choked with softwood waste. Hardwood splinters do more damage.

chippings flying around the cutter causing a hazard and blurring your vision.

Nowadays, most manufacturers pay reasonable attention to the need for extraction. It matters not just for safety, but also for keeping the working environment reasonably tidy and allowing the operator to see the progress of the cut. Most routers take add-on bits which usually come with the machine, while others are available as accessories – which is wrong, of course.

This is, however, less than a counsel of perfection, because these add-on bits tend to obscure the work even though they are usually made of clear plastic. Dust sticks to them and they make it awkward to insert and remove the cutters. The plastic is also going to break or get lost eventually, so there has to be a better way. A few routers have proper built-in extraction, but most just have an add-on plastic spout.

Portable extractors

For proper extraction a small, mobile, portable extractor with automatic power-tool switching is a must (see Fig 3.19). It allows fast and efficient working and deals with the majority of the waste. An ordinary vacuum cleaner is not suitable, although a small industrial model may fit the bill. To my mind, the large router is at home in a table acting as a mini spindle moulder. Here the production of chippings can be prodigious, so a better answer than a small extractor is needed. A High Pressure Low Volume (HPLV) extractor may work satisfactorily, despite the quantity of chippings ejected, if a 'drop box' is fitted between the table and the extractor. The vacuum draws the chippings as far as the box, where most then settle, while the lighter

dust continues on to the extractor itself. This is a cheap way to enlarge collection capacity. You can build a home-made router table with this facility (see Chapter 14).

OPERATIONAL SAFETY

Direction of cut

In Chapter 1 we saw how vital it is to feed the cutter into the work in the correct direction when working on the edge of a workpiece. To reiterate, the feed direction must be against the rotation of the cutter (see Fig 3.20). When machining in the middle of a board, you don't have to concern yourself with this. However, when you widen the cut, this second pass must obey the direction-of-cut rule.

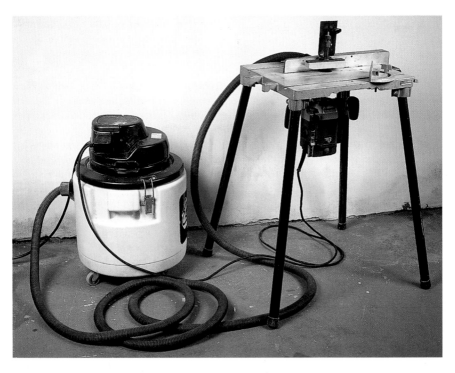

FIG 3.19 A portable extractor and properly extracted table set-up.

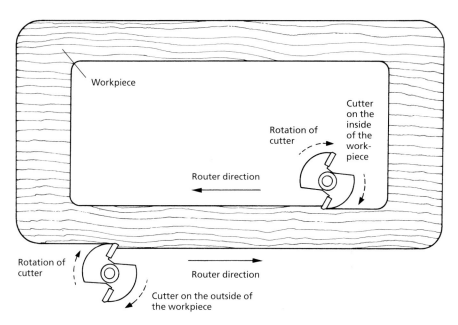

FIG 3.20 The direction of cut. A plan view of internal and external passes.

Table or freehand working

Some work is only possible freehand; some can be carried out either freehand or on a router table; while certain items can only be done on the table. There are several reasons for this. First, there is the size (or lack of it) and stability of the workpiece. Then again the workpiece might already be fixed, leaving you with no choice but to machine it where it is.

Safety is an obvious issue, but so is the quality of the result. Generally speaking, a decent size table will allow the wood to pass smoothly over the cutter, giving good control and therefore a good finish. It is also safer to machine small sections in this way. There are various techniques for dealing with small or awkward sections and these are covered in Chapter 7. Freehand working can mean unintended 'stepping' or damage at the start or finish of a cut where the moulding runs right through and the router is not stable enough. This happens, for instance, when

FIG 3.21 A router fitted with a side handle for greater stability. A home-made MDF or ply sub-base will do just as well.

doing edge work. The use of an extended base or sub base will help here (see Fig 3.21). If you need to put the work on a protective

FIG 3.22 Using a Router Mat.

FIG 3.23 The collet on the left shows some wear which caused the cutter shown in Fig 3.27 to leave the router at speed! Note the resulting bevelled mouth of the collet.

surface – to protect the inverted face of a veneered, lacquered or french-polished workpiece – don't use something loose like a blanket, because it just ends up wrapped around the cutter. Instead, use either a rigid material that will always stay flat or the rather ingenious Router Mat (see Fig 3.22).

ROUTER TABLE SAFETY

This subject is covered fully in Chapter 7, but for now I will say that proper guarding and the use of hold-downs to control the work are essential. Proprietary tables should come with these as standard, while home-made tables can have all these parts made to suit the table.

CUTTER SAFETY

Collet care

The collet, which is held on to the motor spindle of the router by the collet nut, is intimately connected to the shank of any cutter which you may use. Because of this, the safe use of any cutter depends on the state of the collet.

Change your collets at least once a year if you do a lot of routing. Worn collets are responsible for a large percentage of accidents, because cutters come loose and fly out. If you find that the cutter is slipping, this will be the cause. The dynamic forces of machining can cause the collet to 'spread' or become oval, which means that it will not grip a cutter shank properly. Collets are expensive, because of the fine machining required and the quality of the steel, but not replacing a faulty one could cost you more.

If the collet does not stay locked into the collet nut when the whole assembly is undone the nut itself may need to be replaced (some routers are intended to have loose collets) (see Fig 3.23).

Cutter selection and use

Always buy new cutters that are well known high-quality brands. If you are offered any used cutters, be cautious: you could be buying something that has done a lot of mileage or that may have been dropped, so breaking or loosening the inserts on TCT (tungsten carbide tipped) bits. It is possible, too, that the shanks may be damaged or bent from misuse. In other words, never buy a second-hand cutter, even from a friend or colleague: it is too risky.

Cutter care

Cutters also require care and you need to check regularly that they are still fit for use. In particular, they should be sharp. This is a matter of judgement based on visual observation and performance. Does the cutting edge look blunt? Does it look as if it has accumulated burnt deposits or a build up of resin? Are there nicks in the edges of the blade or are pieces missing? Is it hard work making a pass with the cutter and does the wood burn when you do? (see Fig 3.24).

FIG 3.24 The cutter on the left is in good order, while the one on the right shows a worn insert, broken corners, nicked edges and a build up of resin and dirt.

FIG 3.25 Straight cutters: HSS (left) and TCT (right).

If any of your answers to the above questions are positive, then it may be time for a regrind or even time to throw away the cutter if the damage is severe or if it has reached its resharpening limit.

Cutter types

I strongly advise you to avoid using cheap, poorly made cutters if at all possible. Stick to good quality HSS (high speed steel) or TCT cutters (see Fig 3.25). The former are nice to use on softwoods, but have been largely ousted by the upsurge in demand for TCT cutters, which are much better for general work especially in hardwoods and MDF. HSS cutters have a more integral construction, being formed from a solid piece of steel, whereas the TCT cutter has brittle, sintered (powdered

FIG 3.26 Honing the edge of a cutter using a mini diamond hone.

granular metal compressed under high temperature) cutting edges brazed on. This is fine most of the time, but damage to the edges, a weak piece of brazing or a fall to the workshop floor can leave the cutter in a dangerous state.

Cleaning a cutter

Take any suspect cutter and thoroughly clean the debris from it with turps or lighter fuel and a piece of scourer or with the edge of a trimming knife blade. This should be done regularly in any case, because cutting efficiency is reduced by a build-up of grime. Inspect the cutter again, with a magnifier if necessary, and if attention is required don't hesitate to send the cutter to a saw doctor. The cost of many discount cutters means, however, that sometimes it may be just as cheap to ditch the cutter and buy a new one.

Honing a cutter

It is possible to hone the flat face of a TCT cutter with a diamond hone, though you shouldn't attempt this unless you are confident that you can restore the cutting edge properly without affecting the efficiency of the cutter (see Fig 3.26). Honing is the very fine sharpening of a cutter and not to be confused with grinding, which is a more serious removal of the cutting material to get back to a good clean sharp edge.

Shank problems

Other cutter problems can be the result of shanks which have been marked, damaged or even bent (see Fig 3.27). I am told by an expert at Trend Machinery that rising or falling cutters (depending on whether the machine is inverted at the time or not), where the cutter starts to slide out of the collet under load, are due exclusively to worn collets. So replace the collet in question if this seems to be the case (professional users

FIG 3.27 This cutter had a completely straight shank before it slipped out of the router. The cutter itself may still be usable, but the bent shank is too badly damaged. Note, too, the wasted end of the shank.

need to change heavily used collets once a year; DIY users obviously don't need to do so quite so often). Taking this step will protect your other cutters as well as yourself. If you can see that a shank is badly marked or worn, then it really is damaged and should be thrown away. Bent shanks are an amusing little item. Quarter-inch shanked cutters bend if they are asked to do too much, in which case throw them away instantly.

Storing cutters

Cutters should always be kept apart and in a special box or compartment designated for them. If they touch, their brittle edges can be damaged. It is worth having a proper storage pouch or box for each one.

Re-ground cutters

Any cutter that is reground is left with the mass of the backing steel uncomfortably close to the edge of the carbide, and a point is reached where grinding the steel back is the

FIG 3.28 A comparison of cove and roundover cutters shows the large bite taken by the cove cutter.

only solution for longer life. This should be done only to cutters that are large and expensive enough to warrant it, but it is strictly a job for a saw doctor because dynamic balancing is critical for safety. The result of all regrinding is a reduction in size of the cutter profile and possible loss of shape. Matched profile and scribe cutter sets and the like may not function properly after such attention. If in doubt, discuss it with the saw doctor first.

MACHINE SIZE

Which brings us neatly to those age-old questions: Which cutter should I use? What size shank should I go for? Which machine should I use? Popular advice to less-experienced users is: 'get a big router'. That's fine, but a $\frac{1}{2}$in collet router costs a lot of money and if you don't intend to use it a lot there isn't much point in owning one. A small router is much easier to handle, the controls are easier to operate and the

standard of the work can be finer. It can also be successfully inverted in a table.

MULTIPLE PASSES

Taking multiple passes will avoid bent shanks, cutter slippage and a strained motor and bearings and will, of course, produce a nice piece of work without tearout, burns and severe chattermarking.

Setting the depth

Some cutters, such as the roundover, don't take out too much even at full depth, but the opposite profile, the cove bit, which comes with a bearing (unlike the similarly shaped core box which doesn't) takes out a substantial bite and needs to be applied in stages to avoid trouble (see Fig 3.28). Erring on the side of safety means that a $\frac{1}{4}$in shanked cutter should only take out a depth of cut equal to the width of the shank. This isn't entirely realistic, as the example of

roundover versus cove shows, and a bit of common sense needs to be applied when depth setting. The three-stage turret fitted to a router is invaluable for this work and can usually be adjusted to optimize the depth of passes you can take.

Depth setting with the ½in collet router

The ½in collet router is much better suited to heavy and intensive work. Compared with ¼in shank cutters, the ½in shank cutters have shanks which are disproportionately larger than a mere doubling of the diameter. This gives a tremendous boost to cutter size and design as well as the amount which can be cut away in one go (see Fig 3.29).

There are some pretty scary looking cutters for panel raising, cornice and handrail production, but these are intended exclusively for electronic routers in a router table at low speed (10,000rpm). Correct speed is a vital factor, not merely for the safety of the operator, but also to keep TCT cutters intact.

The ½in shanked cutters rarely bend. However, the cutter can start to slide out of the collet if overstrained by excessively deep cutting. Again, use multiple passes where necessary. There isn't a set rule of thumb, but common sense and experience of using

FIG 3.29 ¼in, 8mm and ½in shanked cutters. The ½in has a much larger cutting profile.

different cutters will tell you when you're at the safe working limit. In any case, something like panel raising will benefit from a first pass to remove the bulk of the material and a second pass to clean up and give a good finish.

SAFETY CONCLUSION

It is easy to run away with the impression that the router is a very dangerous piece of equipment. In fact it isn't, but this chapter is intended to alert you to the kind of problems that can occur. If you use common sense and check what you're doing and how you do it, routing will prove to be not just satisfying but, frankly, fun as well.

4

Router cutters

THE ROUTER IS nothing without cutters. For me, choosing and using the cutters is the most interesting and rewarding part, and since I first started in woodworking there has been a huge increase in the variety and types available. In this chapter, I start by looking at the construction of a typical cutter and then examine the basic differences between stamped, HSS, TCT and diamond cutters, not to mention variform (changeable profile) and disposable-edge types. Then I run through the entire 'cast list' of cutters available today. The variety is staggering.

FIG 4.1 An HSS and a TCT cutter. Note the sweeping waveform of the HSS cutter. This allows for easy clearance of chippings.

CUTTER MANUFACTURE

Die-stamped cutters

These most basic of cutters have been phased out now and are hard to find. They are inferior to the alternatives in every way and should be avoided like the plague. They are made from rolled steel. The quality of the steel is poor and the stamped cutter section is quite light with no 'mass' to help it cut or to keep it rigid. These cutters, when equipped with a 'pilot' or guide pin to guide the cutter along an edge, don't do the work any good, because the pin is crudely formed and will tend to burn the workpiece as it rotates. It may even make a dent, especially on softwoods. Their cutting edges are ground reasonably well, but that doesn't make up for the lack of integrity of construction. I failed to find one to illustrate in the book, so presumably this type of cutter has more or less died a death.

HSS cutters

These are now a little rare, having been largely ousted by the TCT cutter, the latter being a much better all-round performer (see Fig 4.1). Nevertheless the HSS variety are quite nice to use. They work best on softwoods, because hardwoods and man-made boards, such as MDF, will destroy the cutting edge quickly. Each cutter is machined from a one-piece steel blank and has two cutting edges. It may have a bottom cutting edge or edges machined into it. The

FIG 4.2 A counsel of perfection: all cutters in their boxes or compartments, easy to find and quite safe.

initial sharpness of the edge is superior to that of a TCT, but this can get lost quite quickly. TCTs have a very much longer cutting life between sharpenings. Honing an HSS cutter is easy although, as always, you need to keep to the original grinding angle if it is to cut properly. Regrinding is strictly a job for a saw doctor.

TCT cutters

Now the most prolific cutter type by far, the TCT seems to enjoy all the advantages, with just a few drawbacks. Tungsten carbide is a very tough metal which is 'sintered' to form a blank. Sintering, as we have seen, is a process whereby the grains of TCT are compressed and 'stuck together' under a high temperature. It follows that the resulting blank does not have the integrity of drawn or cast steel, and TCT is therefore rather brittle. Some cutters are inferior grade, having poor-quality TCT brazed inserts. These have a coarse grain structure, and the brazing itself may not be well done, leaving

some serious weaknesses. The result can be that cutter inserts may fragment or break off completely. Any cutter, however good, may fracture or chip if dropped or brought into contact with another TCT cutter, so careful, separate storage of your cutters is important (see Fig 4.2).

Generally, it is only the smaller sizes of cutter which are made entirely of TCT. This is due to the high cost of TCT compared with steel, which makes up the body of most TCT cutters. The steel also has the advantage of not being nearly so brittle, allowing the shank to bend and 'give' a bit under stress, which is safer. There are two grades of cutter - those for light DIY use and the heavy-duty professional sort. The difference is in the 'build quality'. The DIY versions have thinner carbide tips and less steel in the body of the cutter. It all depends on what usage you expect to make of your cutters. The light cutters are fine for occasional use, though they come in a limited number of moulding styles. The

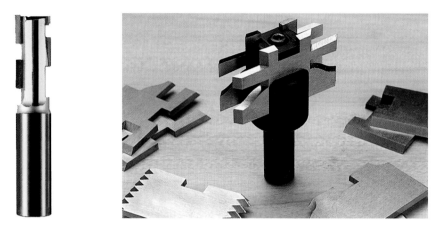

FIG 4.3 A PCD cutter. **FIG 4.4 An interchangeable HSS-bladed 'Le Ravageur' cutter set.**

heavy-duty cutters will allow several resharpenings before they have to be ditched, but that will be after an immense amount of work in many cases. TCT, because of its granular nature, is intrinsically very slightly blunt compared with HSS. However, its ability to keep cutting successfully can be amazing, although it becomes a little hard to judge whether the edge has lost its keenness or not. Beginners tend to work mostly with softwood, so keep your cutters clean, as TCT will blunt much more quickly without care and attention.

PolyCrystalline diamond cutters (PCD)

Studies of TCT cutters working at high speeds have shown that, because of the high temperatures involved when cutting is in progress, TCT actually 'melts' and the edge rounds over a tiny amount. However successful TCT has been, there is clearly still a need to find some superior material for very demanding applications.

One experiment was to use ceramic cutters. Despite being capable of resisting high temperatures, these have some inherent drawbacks, not the least of which is a

brittleness greater than that of TCT. For some time now, there have been diamond-faced cutters for difficult professional applications (see Fig 4.3). These are not intended for amateur use, because they are expensive and unsuitable: they can be used only in large fixed-head machines. The diamonds used are nothing like jewellery diamonds and are incredibly microfine, being coated all over the cutting faces.

Multi-form cutters

These are generally TCT with one or two available in HSS. They have interchangeable cutter 'blocks' rather like tiny spindle moulder blocks which fit on to an arbor or shaft and are locked into place. They are not necessarily cheaper or more efficient, just different. (see Fig 4.4).

Disposable-tip cutters

These cutters are used a lot by professionals who tend to demolish sharp edges just by the sheer amount of work they do, especially with MDF. Basically, the cutter has a shank and a body as usual, but the body is machined to take disposable blades. These are safely located and held down with Torx

or Allen screws. One key advantage is that the cutting diameter always stays the same since no resharpening is involved. However, they are limited to straight or bevel cutters, because these are simple shapes and the ones most often used for repetitive cutting. Interestingly, some blades are made from titanium, which is what the Space Shuttle would have been made of originally if budget constraints hadn't got in the way. Titanium is an extremely tough, almost indestructible material, but even used here for router blades it comes in disposable form, which tells us something about how punishing some kinds of man-made board can be. Disposable tip cutters are of academic interest only to the beginner, especially as there are plenty of good-quality discount TCT cutters on the market which last a good long time in less demanding hands (see Fig 4.5).

CUTTER TYPES

Straight cutters

These are the first and most basic types of cutter that anyone uses. There is quite a lot to them, however, because they come in several varieties and in an enormous range of sizes. Depending on the type, sizes range from a single-flute cutter of just 1.5mm diameter up to a two-flute, with a whacking

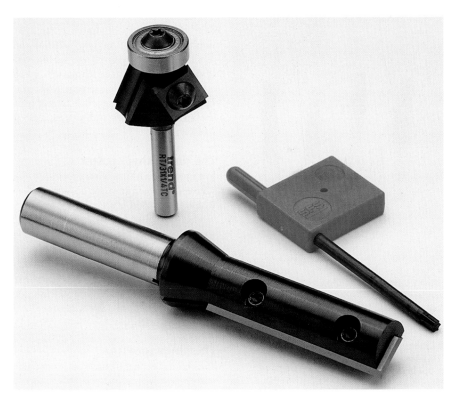

FIG 4.5 Trend 'Rota-tip' disposable cutters and a Torx key for fitting them.

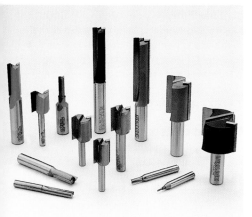

FIG 4.6 (above) A wide variety of straight cutters (these are two-flute cutters, but single-flute cutters are also available).

FIG 4.7 Stagger tooth, shear cutters and hinge mortise bits. Note how shear cutters appear to taper. This is an illusion caused by the spiral cutting edges.

1 Stagger tooth
2 Pocket
3 Down shear
4 Up-down shear
5 Down shear
6 & 7 Hinge mortise

great 50mm diameter. Actual cutter lengths go from a mere 5mm up to about 50mm (see Fig 4.6), although those for deep mortising can be even longer.

The two-flute straight cutter

Considering the rather straightforward nature of these cutters' tasks there is a surprising variety. We start with the standard two-flute pattern which, as its name suggests, has two cutting edges. It may also have a bottom cutter or insert so that it can be plunged into the work successfully. This is the best type to use, because it gives a good finish and is quite strong.

The single-flute straight cutter

The next sort is the single-flute cutter, which does not give as good a finish as the two-flute version since it can take only half the number of cuts at any given speed. However, it does clear away the chippings more efficiently and is available in very small sizes. For a beginner it is perhaps less suitable than the two-flute cutter, unless you have a specific need.

The down shear cutter

We now come to the more exotic cutters, such as the down shear or up-down shear which has angled blades to slice through veneered or solid wood without 'spelching' (see Fig 4.7). This is a term I use often: it refers to the tearing of the wood when a cutter moves across the grain. Woodworkers are always seeking to avoid this, because it looks so bad on a finished piece of work (for more details on this, see Chapter 7 on inverted routing).

The hinge recesser

This is a rather dandy little cutter popular with many cabinetmakers. It is a small, straight cutter with the centre missing at the end of it. This allows good clearance for

chippings when doing shallow recesses such as are required for hinges.

The stagger tooth cutter

Lastly, we have the stagger tooth or pocket cutters. These are normally quite long and can sometimes be used at a greater depth than the length of the cutting edge might suggest. The reason for this is that some of the shank can enter the pocket or mortise, providing that plenty of passes are being taken in order to reduce the strain on the cutter. They are available in small sizes for ¼in routers, and as big boys for ½in machines. You really need to be doing some serious work to want one of these cutters in your set, because they can give you a bit of a bumpy ride.

Working with a straight cutter

Straight cutters are capable of many tasks, because they are less limited in scope than moulding cutters which have just one profile and very particular applications. The following lists show the range of jobs they can undertake:

- apply inlay and stringing to boxes or furniture (see Fig 4.8)

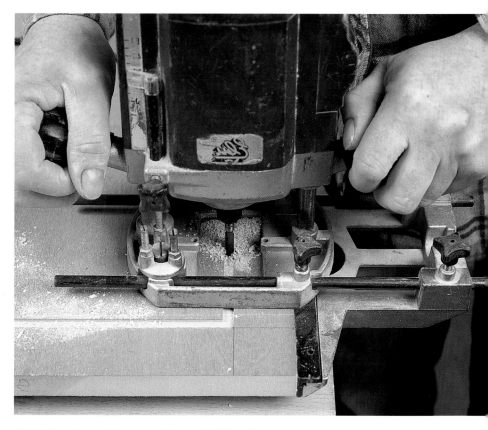

FIG 4.8 Grooving a table top ready for an inlaid banding.

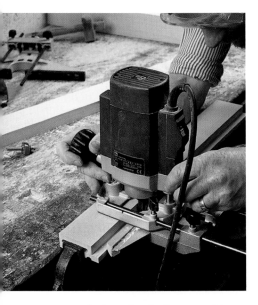

FIG 4.9 Rebating using the fence to guide the cutter.

FIG 4.10 An open tongue and groove joint.

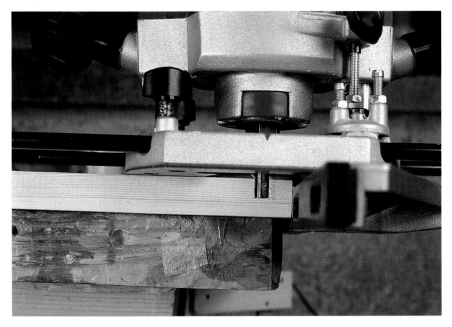

FIG 4.11 Grooving a cabinet to take a thin back panel.

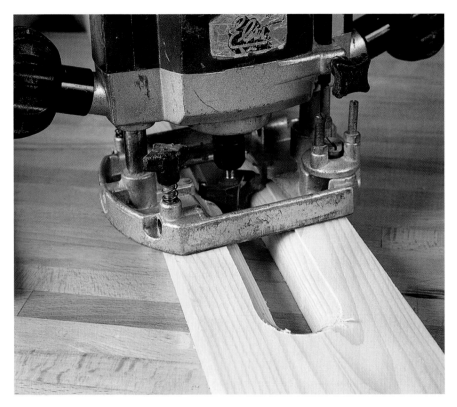

FIG 4.12 A bearing-guided cutter following a straight slot. Note that for safety reasons the slot is wider than the roundover cutter so that it doesn't catch both sides at once.

- machine frets on electric guitars
- carve fine detail and shapes freehand
- trim boards to size
- plane edges
- produce slots of any width
- produce rebates (steps) (see Fig 4.9)
- add decorative detail
- make slots on board edges
- make loose tongue and groove joints (see Fig 4.10)
- make finger joints on boxes
- make a groove for a weatherseal on a window frame
- produce classical dentil (tooth pattern) moulding
- fit back panels into kitchen cabinets (see Fig 4.11)
- drill holes
- make mortises for table and chair legs
- make mortises for door locks
- work with templates
- make grooves which can then be followed by a bearing-guided moulding cutter (see Fig 4.12).

So you can see that, although I haven't given an exhaustive list of applications, the boring old straight cutter is anything but limited. It is in fact the most useful of all the cutters you are likely to own.

Roundover/ovolo cutters

These are less functional, but a very basic start for decorative moulding. They can be used to follow on from a straight cutter. You might start with a nice square edge or groove and then elect to use the roundover to produce a profile off that. The term roundover is self explanatory, but ovolo is a traditional term for a regular convex curve with one or two small shoulders or steps. This immediately adds a certain classical decoration which the pure roundover on its own does not (see Fig 4.13). The same cutter can produce either a roundover or an ovolo, the only difference being the size of the bearing which is used to guide it along the workpiece. A bearing smaller than the cutter edge ensures that the step is cut. Equally, by setting the cutter down below the flush height of the work, it will ensure that the other step is cut, too. The roundover is good for modern work, while the ovolo looks more comfortable with reproduction styling.

One advantage of an ovolo cut is that it can be used to mask slight surface discrepancies, such as those between a veneered board and a 'planted on' solid lipping which needs moulded decoration. Don't buy cutters that come with just a guide pin or pilot, because they will burn or even dent the wood due to friction. The only good reason for using pin-guided cutters is to follow intricate shapes that a bearing cannot do well because of its larger diameter (see Fig 4.14). This applies to most types of cutter. Instead, choose a cutter that will take interchangeable bearings, perhaps in several sizes. This will allow one cutter to do several different jobs. Cutter sizes can vary between a mere 3.2mm radius up to about 38mm for use in static set-ups. The smaller sizes are fine for the beginner.

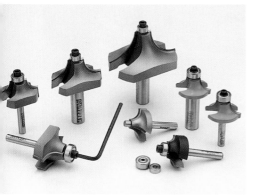

FIG 4.13 Roundover/ovolo cutters. Different bearings determine the resultant step, or no step, as the case may be.

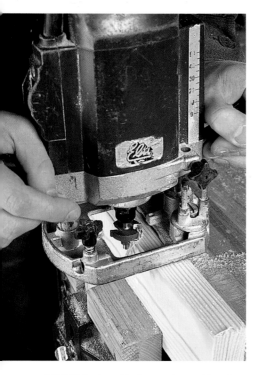

FIG 4.14 A pin-guided cutter in use. The pin has dented this softwood leaving a track along the side.

Cove and corebox cutters

These two are the opposite of the roundover/ovolo, because they produce concave rather

than convex mouldings. Unlike the roundover/ovolo, these two cutter patterns are quite separate types, for technical reasons (see Fig 4.15). Both have disadvantages compared to the roundover/ovolo. The main one is the amount that they have to remove when cutting. If you take a small square section of wood and draw a diagonal from one corner to the other, then hold a roundover on the end face, it is apparent that only a small amount of wood will be removed to form the moulding. However, if you hold a cove cutter in place, you can see that most of the square section will be cut away to make the profile. The dynamics involved mean that a lot more stress is applied to both router cutter and workpiece. The finish will also be bad. To avoid straining the motor and possibly bending the cutter shank, the sensible course is to make several passes. The steps will not be constant ones. The first pass will take out relatively little, while the successive passes will remove much more. A little common sense is needed when setting the depth each time.

Unlike the cove, the corebox cutter has no bearing. This means that it can be used for bottom-cutting work. The downside here is that if you look at the very centre of the cutter tip, it will be apparent that the two opposing cutting edges meet. Simple science tells us that the smaller the diameter of an object, the lower the speed. Therefore, at a cutter's outer edge it will be travelling fast, but at the centre it is going, relatively, quite slowly. In fact, at the very centre (probably an atom's width) the cutter is actually standing still. In practical terms, this means that a cutter travelling slowly causes more friction, is more likely to burn the workpiece and will not be able to move in a straight line properly. Corebox cutters are very useful, but they do need to be sharp and, as always with fence work, you need to pull the router towards you so that it is less likely to wander off course. And lastly, don't

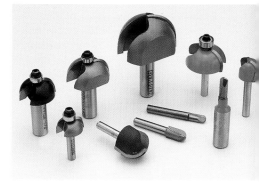

FIG 4.15 Coving and corebox cutters. The smaller sizes are the most useful ones.

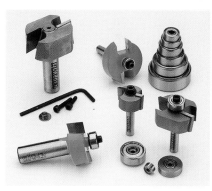

FIG 4.16 A selection of rebaters including CMT 'Master Rebate Set' (multi-bearing type).

linger in one place with a corebox cutter, because it will burn the workpiece.

Rebate cutters

The rebate cutter, or in old parlance 'rabbet' from the French 'rabot' or 'plane', is invaluable as a basic cutter and should be included in any set.

Unlike the straight cutter, the rebate has a shallow cutting depth but a wider diameter due to the guide pin or bearing. I should explain that cutters don't automatically come with or without bearings or guide pins, and

in some cases they can take a bearing as an optional item (see Fig 4.16). In this case, a rebater isn't a rebater without some sort of guidance. What makes it so useful is the ability to take the corner out of a square profile with accuracy, and to follow the contour of the workpiece whatever shape it is. Thus a task such as rebating the back of an assembled mirror frame is easy. If you have different sized rebaters, it is possible to cut a second step for the board that will

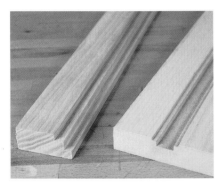

cover the mirror and hold it in place (see Fig 4.17). There are many other uses of course. As with all bearing guided cutters, the rebater will follow any defects in the wood, so a missing knot or tearout will result in a kink in the line of the rebate. Any such faults should be made good before machining. Nowadays it is possible to get a large rebater and a set of bearings to cover all useful sizes of rebate. It's a very handy cutter to have.

Trimmers

These are for making one surface flush with another. An example would be levelling a solid strip inset into a table top or perhaps neatly finishing the laminate on a kitchen worktop. Most trimmers have a bearing, but a few do not and require a fence instead (see Fig 4.18). Trimmers vary in length. The large ones are ideal for heavy, templated profile work such as electric guitar bodies or dining chair legs (see Fig 4.19). Most are straight, although some are bevelled or

FIG 4.17 Stepped rebates. The one on the left would be suitable for holding glass and backing in a picture frame, the other is intended to hold 'Tonk' or library strip for supporting shelves.

FIG 4.18 A selection of trimmers.
1–3 Template trim
4–8 Panel trim
9 Pierce and trim
10 Laminate trim
11 Surface trim
12–15 Laminate (15 is a Rota-tip)

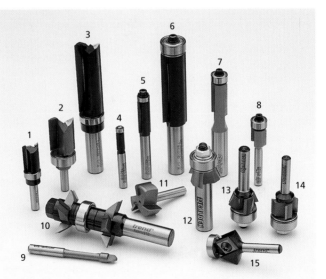

FIG 4.19 Heavy profile work. Note the burns on the upper part due to cutter wear from template working. 'Sticky' gloves give a non-slip grip on the wood.

FIG 4.20 A selection of bead and reed cutters.
1 Sunk mould
2 Cove and bead
3, 4 & 7 Beads
5 & 6 Edge beads
8 & 9 Reeds
10 Reverse effect (fluting)

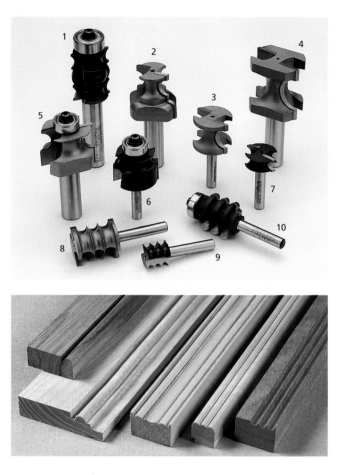

FIG 4.21 From left to right: edge bead, classic bead, sunk bead, reeding and the reverse effect (fluting).

double bevelled for laminate trimming in either one or two passes. Unless you are intending to do a lot of worktop trimming, the long profile pattern is probably more useful.

Beads and reeds

These are other examples of traditional or classical moulding shapes that have transferred successfully to modern routing technology. The bead is a single roundover shape which can be semicircular in profile and is usually accompanied by at least one shoulder. There are various types, such as the staff bead, the corner bead and the sunk bead (see Fig 4.20). The bead can be extended in profile by the addition of other features, as with the classic staff bead (see Fig 4.21). The corner bead variety usually has a bearing though the other types may not. The reverse (concave) type of cutter is also available.

Where several small beads are grouped together to form a more intricate profile, it becomes a 'reed' cutter. This more delicate effect has many uses, such as on chair legs and table edges and for generally 'prettying up' otherwise plain surfaces.

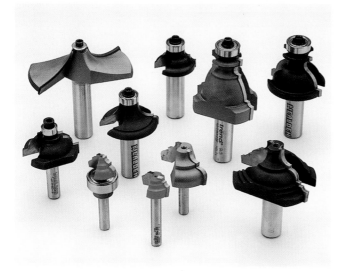

FIG 4.22 Edge and decorative cutters.
1 Thumb mould
2 Bolection
3 Bullnose
4 Cavetto

The bead cutters have their own uses, being very suitable for the edges of window ledges and cabinets. The corner bead is ideal for corner detail on legs and also to form a 'door bead' where two doors meet. In this situation two flat surfaces together often look plain, and if they are not level, or if the gap between them is unequal, it shows. The bead cutter is another useful item to have in a basic set.

Edge or decorative moulds

These form a group of cutters which add useful detail to an exposed plain edge or surface. Included in the group are some of the bead, reed and ovolo cutters already mentioned as well as some more exotic varieties (see Fig 4.22). These cutters are often elaborate and large, but they add substantial amounts of moulding detail that would otherwise be lacking. Unfortunately, some need a 1/2in collet router, and most of them are traditional profiles which do not look appropriate with modern styling (see Fig 4.23). One cutter of note is the bolection. Among other things, it is often added for detail around panels in frame and panel construction. This is one group of cutters that has benefited very much from the revival of traditional moulding plane profiles such as the 'lamb's tongue'.

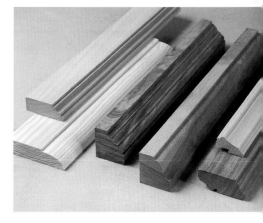

FIG 4.23 Various edge moulds, including cavetto (top left), thumb mould (bottom left), and bolection (top right), complete with a rebate on the underside to allow it to sit on a square frame edge.

FIG 4.24 A selection of joint-forming cutters.
1 & 2 Finger joint
3 Lock mitre
4 & 5 Glue joint

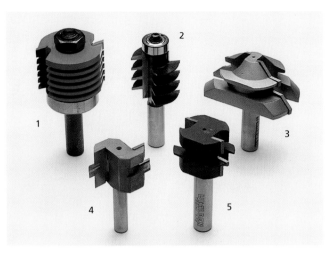

Jointers

Some jointing cutters can be purely functional (see Fig 4.24), while others, such as the profile and scribe cutter, also lend aesthetic details to the workpiece. The finger joint cutter provides a positive and extremely solid joint between edges. There are one or two drawbacks, however. First, like most joint cutters, it is only available with a ½in shank. Secondly, it is necessary to prepare the components carefully. The two opposing faces of the joint are both machined face down on the router table – one must then be reversed to assemble the joint. This means that the thickness of everything has to be exact if you are to end up with a level or 'flush' joint. The edges need to be planed true as well. Wood being wood, it can still change shape overnight: when this happens, persuading it to run absolutely flat across the router table is a little difficult. Often the wood will require sanding with a belt sander to level any inconsistencies after assembly.

To be successful, joints need to be 'defluffed' with abrasive paper, lightly glued and strongly cramped. The result is

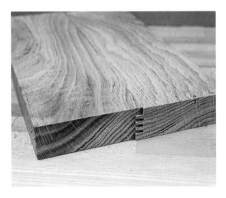

FIG 4.25 An assembled finger joint.

impossible to break, however, and is ideal for multi-strip kitchen worktops, butchers' blocks and the like (see Fig 4.25).

There are other jointers, such as the lock mitre which is used in drawer-box construction. Again, the work will benefit from careful preparation, machining and assembly. Lastly, one or two classical panel sets are available. These are not the full 'profile and scribe' type which have decoration, but they form part of a joint construction after the tenon and groove part

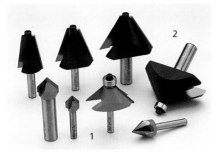

FIG 4.26a Bevel and V groove cutters. The bevels at the rear will accept bearings. Front right is a CMT Patrick Spielmann 'Laser point', which is ideal for freehand carving. Nos. 1 and 2 are chamfer cutters

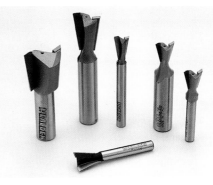

FIG 4.27 A selection of dovetail cutters. The one on the left is for stair housings. The small to medium sizes are the most useful.

FIG 4.26b A V point or bevel cutter. It has been used to bevel the reverse side of some oak panels for a linen chest.

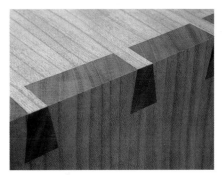

FIG 4.28 The very best machine-cut dovetails can look as good as this hand-cut example.

Chamfer, bevel and V-groove

Both of these cutters provide a simple and easy way to add detail to nearly anything. The chamfer is bearing guided and tends to give a cut of 45° or steeper. The V-groove has a point, and no means of guidance apart from the router fence. The chamfer is perfect for following a shape and is effective for creating 'stopped chamfers' on all kinds of woodwork including *in situ* work, on a square newel post for example. The V-groove is good for adding surface detailing, and can be used freehand or with a template for

carving or making a name plaque for a house. Each has a place in a basic cutter set (see Figs 4.26a and 4.26b).

Dovetail

The role of the dovetail router cutter has expanded over the years. It now comes in sizes and varieties to suit anything from cutting stair trenchings and housings (in order to create complete staircases) to the construction of small boxes (see Figs 4.27 and 4.28). Some cutters are designed to work with specific dovetail jigs such as the Leigh

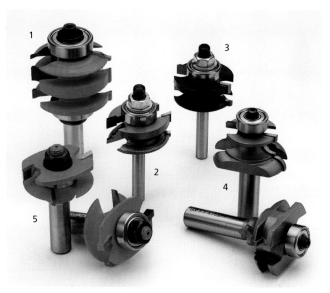

FIG 4.29 A selection of profile and scribe cutters. Nos. 1, 2 and 3 are the reversible type, the others are matched pairs.
1 CMT combination cutter
2 & 3 Wealden reversible cutters
4 Large two-piece set
5 CMT two-piece set

or Incra jigs. The results produced can be awe-inspiring pieces of fine cabinetwork, but these jigs have a price tag to match. There are simpler jigs available (see Chapter 9 for more details), which can be useful if you are keen to make dovetailed joints. Dovetail cutters can also make housing joints which are a very strong method of carcass construction.

Profile and scribe

The advent of this type of matched cutter set meant that for lightweight cabinet doors, conventional mortise and tenon joints or the less effective dowel joint were no longer necessary. What is more, there are several different moulding profiles available (see Fig 4.29). The moulding holds the centre panel in a slot behind, which also forms one half of the joint. A scribing cutter is used to form the other part of the joint and the 'counter profile' which 'plugs' into the other component. This is needed four times to make a complete door frame, but in practice it is quite quick, because all the scribing cuts are done first and then all of the profile cuts. The frame is

completed by a light sanding and gluing up. To make the panel you need a panel raising cutter. The panel is inserted before the frame is glued up. The results are efficiently made, strong and attractive doors. The various moulding styles include bevel, ogee and classical. These sets are only available in 8mm and 1/2in shanked versions.

Panel cutters

These come in two types: the panel raiser, which produces a panel to fit in a door frame, for example, and the face mould which applies a moulded effect on to the face of a board. This could be used in a variety of ways: to break up a plain surface or to decorate the edge of a drawer front (see Figs 4.30a and 4.30b).

The largest sizes of panel cutters will fit only into a ¹/₂in router, but the smaller types will fit an 8mm collet on a smaller machine. The panel raiser is now available as both a large flat-type cutter or a smaller vertical-type which will fit into small router table openings. In fact, most must be mounted in

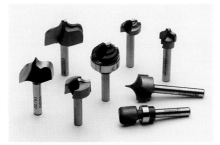

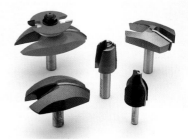

FIG 4.30a Face moulds, designed to cut into the face of a workpiece. Some work with templates, using a bearing.

FIG 4.30b Panel raisers, among the largest cutters available. The vertical types can be used in smaller routers though the orange CMT cutter shapes the reverse side, too.

a table for safety. The small face mould patterns are quite nice for decoration and one could usefully be included in any basic set of cutters.

Miniatures

A fairly new idea is cutters to make miniature-sized mouldings for dolls' houses. Making dolls' houses is a popular activity and these cutters make it possible not only to make the dolls' house itself but to do all the

joinery and 'second fixings' as well (see Fig 4.31). A lightweight router of 400–600 watts is sufficient, because these cutters remove only a tiny amount of wood. All the typical mouldings are there: skirting, cornice and beading, dado and so on. The technique with these cutters is the same as with any small moulding. You machine the edge of a wide board and saw the moulding off, repeating as many times as necessary to get the required quantity of moulding.

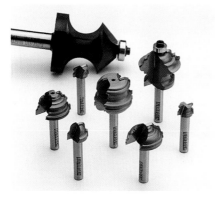

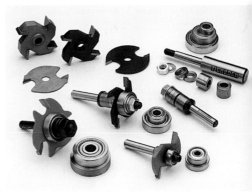

FIG 4.31 A selection of miniature cutters. The full-size torus cutter at the back gives an indication of scale.

FIG 4.32 Groovers and biscuit cutters. Arbors, groovers, bearings and spacers are all interchangeable and cutters can be 'ganged' on ½in arbors.

Slotters

Slot cutters or groovers are for functional rather than decorative use. In effect, they are like mini saw blades with just two, three or four teeth. They are however more versatile than this suggests. For a start they normally fit on to an arbor, or shaft. The shaft can usually take a combination of these cutters with, if required, exact and adjustable spacing in between. They vary in thickness from 1.5–11mm ($^1/_{16}$–$^7/_{16}$in), while the diameters run from 36–50mm

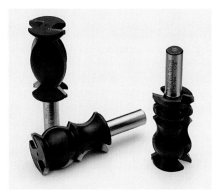

FIG 4.33 Cornice cutters. These are strictly for large routers, but the results are impressive.

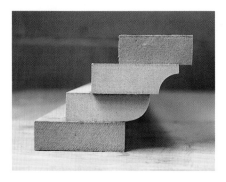

FIG 4.34 A built-up cornice, using just two moulding profiles.

($1^7/_{16}$–$1^{15}/_{16}$in), or even to 100mm ($3^{15}/_{16}$in) exceptionally. Another feature of these is that you can put bearings on the arbor (see Fig 4.32).

These cutters can be used to make tongue and groove jointing, matchboarding (sometimes called TGV – Tongue, Groove and V) and biscuit jointing, and for slotting window frames to take weatherseals. In the last role, the cutter and the arbor have to be special threaded types, thus allowing you to cut flush to the inside of the frame without the usual projecting shaft and nut.

The biscuit jointing option is interesting because, for a reasonable cost, it is possible to perform many of the jointing operations that would normally need a separate biscuit jointing machine. It isn't quite as quick or convenient, but it is a good substitute and has an advantage over a jointer in that it can be used on curves or angled shapes.

Cornice cutters

Most pieces of full-height cabinet furniture, including kitchen cupboards and wardrobes, are topped off with a finishing moulding known as a cornice. This projects and lends the work a look of importance and completeness as well as being an attractive detail. There are now plenty of cutters for this purpose and they tend to be fairly large (see Fig 4.33). They can be 60mm long, depending on the pattern, so they are strictly for the large router. In lieu of such a machine, or cutter for that matter, it is possible to build up a cornice in stages, moulding each stage on a separate piece of board, before gluing the whole lot together (see Fig 4.34).

Ogee cutters

The ogee is a classical shape which has survived into the twentieth century. The two basic patterns are the Roman and the Grecian. The Roman is a regular in-out wave

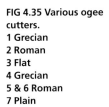

FIG 4.35 Various ogee cutters.
1 Grecian
2 Roman
3 Flat
4 Grecian
5 & 6 Roman
7 Plain

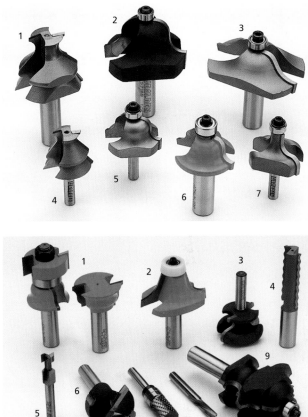

FIG 4.36 A selection of exotic cutters.
1 Sash bar (window bar) set
2 Corian
3 Drawer pull
4 Corian
5 Keyhole
6 Hinge sinker
7 Burr
8 Acrylic
9 Multi-profile

form, while the Grecian is a much fuller and less symmetrical shape (see Fig 4.35). Each has its uses, and which you prefer is really a matter of taste. The Roman type can be broken in the middle by a quirk or step thus producing what is known as a 'classic style' cutter. Ogee cutters may or may not have bearings, and the shape often turns up on frame and panel cutters as well.

SPECIALS

Some of the most useful cutters are perhaps not on the list of what one might call 'basic'

cutters. They do deserve mention, however, so here is a round up of these more exotic items (see Fig 4.36).

Side profile cutters

Once upon a time, moulding handrails was the exclusive preserve of the spindle moulder, but not any more. Trend in particular have created a range of three-sided moulding cutters which, allied to their other cutters, give a range of nine shape combinations. If you fancy making up something a bit different for your home, this could be just the thing.

Drawer pull

Making decent drawer pulls can be a nuisance, but again there is a good choice of cutters which are designed to be used in a number of ways.

Corian cutters

Nowadays, Corian worktops are fitted in expensive kitchens and bathrooms. There is now a whole range of cutters designed specifically for working with this material, with nylon-sleeved bearings specially designed not to mark it.

Aluminium cutters

There are various burrs and rasps and special spiral cutters for aluminium, designed for the double glazing industry.

Drill bits

Drilling is not just the preserve of the cordless or mains drill. The router is better equipped to do this job where wood and plastic is concerned. Routers have plenty of power, they run at high speeds and they cut exactly perpendicular to the worksurface and to a precise depth. Ordinary straight bits do

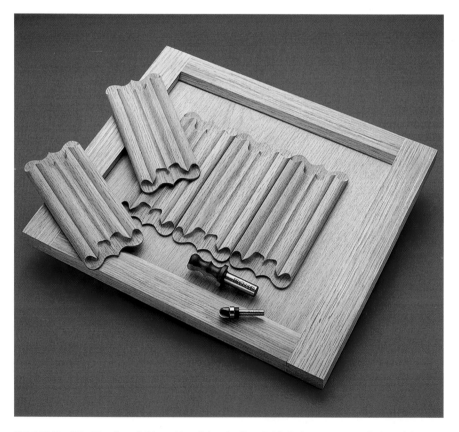

FIG 4.37 The Wealden linenfold set. Note how the linenfolded plaques are applied to plain panels.

quite a good job, but there are also some special spiral drill bits that are capable of countersinking. They don't cut to a great depth but do have some uses.

Hinge sinkers

Another good idea is the hinge sinker for fitting kitchen cabinet hinges. Used with a router and fence, it is possible to get very accurate drilling without accidentally going through to the front of the door frame.

Linenfold cutters

A last and rather exciting cutter development is the linenfold cutter set from Wealden Cutters. This brings a traditional and very stylized moulding pattern within reach of the average router user. Formerly, this would have been the province of a woodcarver equipped with carving chisels and a set of ancient moulding planes (see Fig 4.37).

Customized cutters

Some cutter suppliers can make a 'special profile' cutter to order, but this is expensive, so don't consider it unless you have a very special requirement that can't be met by a standard cutter.

CHOOSING A STARTER SET OF CUTTERS

Having read all the foregoing descriptions you may feel distinctly dazed and confused by the sheer diversity of cutter tooling. It is only fair that I try to suggest what priorities you need to consider when selecting cutters.

To start with, if you are a novice don't think of buying a big $\frac{1}{2}$in router. Choose a $\frac{1}{4}$in model, either fairly small or capable of taking an 8mm collet size, with power to match, if this suits your needs. This begins to narrow your cutter choice straightaway.

Nearly all cutter manufacturers and suppliers produce starter sets which include all the popular items that a new user is likely to need. These represent both a good choice and good value, because the cost of a set in a box or case is lower than that of buying the cutters separately (see Fig 4.38). You can expect to pay £80 for a set and possibly quite a lot more, depending on what is offered and the grade of tooling. Since the cutters are what it is all about, it makes good sense to equip yourself properly, and these cutters will repay the initial outlay by returning good service for a long time if you look after them properly.

A set will usually consist of the following:

- two straight cutters
- a bearing-guided trimmer
- a rebater
- a V groove
- a corebox
- a cove
- a dovetail
- an ogee
- two roundover/ovolos
- a chamfer cutter.

There are variations on this, including different cutter sizes or perhaps several of one type, but this initial group will cover most circumstances if used with a bit of imagination. Obviously, the really big and exotic profiles come in $\frac{1}{2}$in shank size, but you have to start somewhere and learn about routing and cutters in the process.

The Anthony Bailey advanced cutter selection

My own taste in cutters tends to include the following, which you may find a useful guide. These are all TCT cutters. Some are available only in $\frac{1}{2}$in shank size, and they should be regarded as additional to any starter set you may have:

- a 5mm ($\frac{3}{16}$in), two-flute, straight cutter for drilling stud holes to support shelves

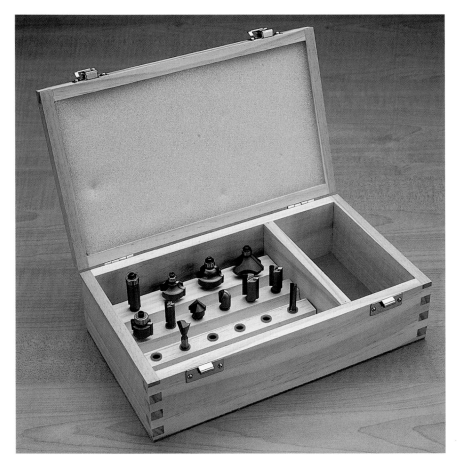

FIG 4.38 The Wealden starter set (with extra space for more cutters).

- a 35mm (1³⁄₈in) hinge sinker for quick and precise drilling of hinge holes in kitchen cabinets
- long stagger tooth or pocket cutters for mortising (in 9.5, 12.7, 16 and 19mm [³⁄₈, ¹⁄₂, ⁵⁄₈in] diameters)
- a classical pattern profile and scribe set. These are good for cabinet doors or room panelling
- an ogee or bevel pattern profile and scribe set (excellent for kitchen and other doors)

- a large bevel panel raiser for making door panels
- a 'regency' panel raiser for a more sophisticated look to door panels
- roundover/ovolo cutters in 3.2, 12.7mm (¹⁄₈, ¹⁄₂in), and larger, (the smallest of these gives a tiny, but distinctive, finish to the edge of a modern piece of furniture)
- cove cutters in 12.7mm (¹⁄₂in) and 16mm (⁵⁄₈in) or larger sizes (useful for making built-up cornice, among other things)

- corebox cutters, 9.5 and 16mm ($^3/_8$ and $^5/_8$in) (the 9.5mm ($^3/_8$in) is ideal for doing flutings to give a mock column effect on a piece of furniture)
- 6.4 and 9.5mm ($^1/_4$ and $^3/_8$in) corner bead cutters for door meetings in order to disguise discrepancies between doors, and for adding detail. This is also good for detailing the corners of table legs, and so on
- a biscuit cutter set (this is ideal, even with a small router, as a substitute for a jointing machine. It won't do everything the jointer can, but it will do normal edge-to-edge or corner joints and, unusually, it will make joints on curves and in other difficult situations)
- hinge mortise cutter in 12.7 and 16mm ($^1/_2$ and $^5/_8$in) sizes (these make a neat, quick job of setting-in brass butt hinges and will do other shallow surface work as well)
- a large Grecian ogee profile is perfect for beautifully finished skirtings and plinths (a plinth is the slightly projecting base moulding on some types of furniture).

The above selection doesn't even begin to describe all the cutters I own or have owned, because as a cabinetmaker and joiner I have used routers and cutters extensively. However, it does represent some of the most useful cutters that I have in my storage box at present.

In conclusion, my advice is to begin with a starter set of about a dozen $^1/_4$in shanked cutters and then build on that as your interest develops. In the succeeding chapters (and the project chapters in particular) various cutters are used or described. This will help you to form your own list. Choosing cutters is a very big subject, and it is a good idea to take advice from magazines, books and other users before spending large amounts of money on those that might see little actual use.

In particular, you should avoid large and very complex moulding profiles unless you really think you will have repeated uses for them – it's better to try building up more elaborate shapes with simple profiles used successively. See more on this subject in Chapter 7: Inverted routing.

5

Basic handheld operations

THE STRAIGHT FENCE

FOR MOST OPERATIONS, the router needs proper directional guidance. The most common method is to use the straight fence. Routers are always supplied with such a device, and there are two holes machined into the base of the router to take the fence rods. These allow you to fix the fence at a certain distance from the cutter.

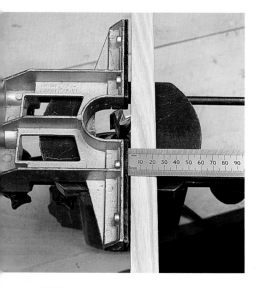

FIG 5.1 Using a ruler and a straightedge to adjust the fence on the router.

Fence adjustment

Fences vary in sophistication from simple pressed steel to neat alloy castings or even tough moulded plastics. With the basic sort, adjusting the fence is just a matter of slacking off the locking knobs on the router base and pushing the fence in or out and then relocking. It has long been recognized that this is not ideal, because quite fine adjustments are sometimes needed, especially for critically accurate work (see Fig 5.1). Router manufacturers have come up with various solutions, but sadly they don't all work as well as intended. Before buying a router which has a fine fence adjustment it is worth trying it out to see how well it works. It should be just a matter of unlocking one

FIG 5.2 Adjusting the plastic facings on a fence.

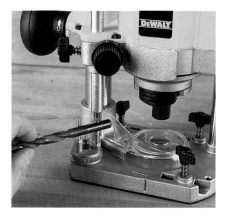

FIG 5.3 Ron Fox, routing expert, recommends using drill shanks to give exact depth settings, though it isn't really necessary with a geared depth rod as shown here.

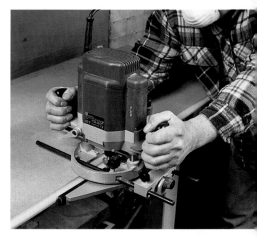

FIG 5.4 An expert operator pulling the router towards himself.

knob and twisting another so that the fence can move smoothly in or out. In practice this degree of adjustment, though nice to have, is not always essential, and a gentle tap or nudge of the fence will often get it into the correct position for locking.

Usually a fence will have adjustable plastic facings, which can be moved as near to the cutter as it will allow for a nearly continuous surface. This makes accurate machining possible (see Fig 5.2).

Using a fence

The normal procedure for machining is to set the fence-to-cutter distance first and only then to set the depth that you wish to cut (see Fig 5.3).

When machining, it is necessary to apply a bit of side pressure to keep the fence firmly against the side of the work. Any lumps or bumps on the side of a workpiece will push the fence off course and spoil the cut. Get into the habit of pulling the router towards you, because a pushing action often causes the machine to wander off course in the direction of the fence (see Fig 5.4).

It is fairly safe to cut the far side of a wide slot, i.e. the side furthest from the fence (see Fig 5.5). This is because if you go off course you'll only be cutting into wood you won't be needing anyway. The nearside is more critical, because any deviation will mark the wood that you wish to keep. Sometimes there are ways around this problem (see Chapter 6: Jigs and templates).

FIG 5.5 Machining the far side of a recess to avoid cutting into good material.

FIG 5.6 Working with two fences.

FIG 5.7 An overlong workpiece will give the router base more support and help to keep it level.

Fence rods

The more expensive routers have fence rods which are separate from the fence. This makes it possible to work near to projecting surfaces that the rods might otherwise catch unless they are adjusted out of the way. Another advantage is that for working on narrow workpieces it is possible to buy another fence which fits on to the other end of the rods. With these tight against the workpiece, and with the cutter in the correct position, there is no danger of the router wandering off – it is rather like a train sitting on the rails (see Fig 5.6).

If the fence rods are fixed they tend to be short. There is, therefore, a limit to the distance the cutter can be from the edge of the work. In this case other means of guidance become necessary (see the section on straight edges, p 73).

Supporting the fence and router base

One error which everyone makes, including professionals, is not allowing enough extra material at the ends of a workpiece to give support to the fence and router base. Because of this, nasty dips or 'dig ins' result and this mars the work. Make sure that your workpiece is longer than it needs to be, even if this seems wasteful (see Fig 5.7). You can usually trim it down with a jigsaw, a circular saw or even the router itself – an excellent board trimmer.

When a component must be machined at its finished size it may be possible to fix a longer piece of material alongside the workpiece. This will at least give support to the fence and the router base. The only problem that remains is providing the rest of the support by holding the router very carefully (see Fig 5.8). A better solution is to build or buy a router table (see Chapter 7). You will find that this is an excellent way to give better support than is possible with handheld operations.

ROUTING ON NARROW EDGES

It is quite possible to use the router on narrow edges, but it does need a steady hand and a good eye to ensure that the router is sitting on the edge squarely. It may be that the fence is on the inside of a carcass, in which case the fence will hit the inside corner of the carcass and prevent the cutter from reaching the corner. The best plan is to think through any project you have in mind and try to do as much routing as possible

FIG 5.8 A clamped-on extension strip for rock steady routing. If this strip is placed next to the fence it also prevents the fence from waggling about at the end of the cut.

before you assemble it. It's much easier to work on individual components than struggling with something that has already been put together (see Project Chapters 10–15. These give the order in which things should be machined, and will help you to understand the need for planning and organizing your work methods.)

EDGE PLANING

It is possible to use a router and a straight fence for planing the edges of short workpieces. Trend used to produce such a device for ELU/Dewalt routers, but it is no longer available. Normally a big planer machine has surface tables that are at least 1m (3ft 3in) long. This ensures that edges are 'true' over some distance. The router fence isn't very long, so don't expect super accuracy, especially with long pieces of wood. Still, it is another way of getting the router to prepare your materials as well as do the mouldings.

To turn your fence into a planer fence, buy a short roll of melamine edging tape from a DIY store and iron it down on to the

section of fence on the 'outfeed' side of the cutter (use an old iron). To identify the outfeed side, fit the fence and, with a cutter in place, choose the fence section from which the cutter will rotate away when in operation (see Fig 5.9). This is the correct fence section, because as the workpiece moves past the cutter it will take off a given thickness of wood in the way that a planer does.

FIG 5.9 A fence to which tape has been added for edge planing.

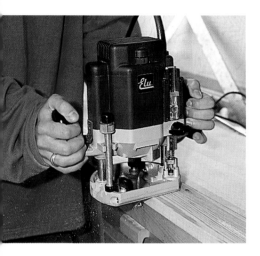

FIG 5.10a Edge moulding a piece of pine.

FIG 5.10b Using a template, with the workpiece underneath. Note the lead-in finger.

FIG 5.10c 'Fielding' a 'cathedral top' kitchen door panel with a flat ogee guided cutter.

The workpiece needs support equivalent to the thickness of the material which is machined off, which is where the tape comes in. Apply one or two thicknesses of tape to the fence edge and let the glue harden. Too many layers will result in too much being taken off in one go. Now, using the edge of a steel rule pressed flat against the taped outfeed fence section, adjust the fence so that the cutter is flush with the tape. Before planing, ensure that the edge of the wood is reasonably well sawn so that it is fairly straight to start with, and then run the router along the edge to give a clean finish. Check the trueness of the edge with a steel rule or even by eye. If it isn't straight, apply the router to the offending section only, levelling that part, then run the router along the entire edge to get a neat and true edge.

BEARING-GUIDED CUTTERS

Many of today's cutters come with a bearing or bearings. This allows you to work along awkward or shaped edges rather than just straight edges. Figs 5.10a, 5.10b and 5.10c show how diverse table operations can be. Cutters sometimes come with a guide pin (or pilot). These can be useful, because they can get into tight corners, unlike many bearings, but should be avoided even if the cost seems more attractive. The guide pin can dent the workpiece and the friction it creates can burn it. Cutters that come with more than one size of bearing give different effects and increase the cutter's versatility for little extra cost. Fig 5.11 shows the effect of changing bearings.

Some cutters don't need bearings fitted because the bearing would simply get in the way of operations (such as plunge cutting with a straight cutter). Others, like the rebater, cannot function without a bearing or fence, so any set of cutters needs to have a mixture of both in order to satisfy the various machining needs.

FIG 5.11 Router diversity: different results obtained by using the same cutter with different sized bearings.

The bearing is located at the end of the cutter spindle. It is held on with a small Allen screw and a washer. It is possible to cut without the bearing in place. This can be useful when the bearing is too large or too small for the job in hand, but you need to use a straight fence or a router table so that the cutter remains guided.

Bearing-guided cutters are equipped with bottom- or top-mounted bearings. If these cutters are resharpened, it follows that the bearing will be slightly too large once the cutting edges have been ground down. It is not usual practice to grind the bearings to match, so the user just has to accept that there is a size discrepancy.

USING A STRAIGHTEDGE AND GUIDE RAIL

There are times when neither a fence nor a bearing-guided cutter will do. The straightedge is what you need if you want to make a long straight cut or a cut well away from the edge of a workpiece, to 'true up' an uneven board edge or even to cut it to length.

The most basic method is to use a piece of wood or a strip of 18mm (³⁄₄in) MDF about 125mm (5in) wide. It should be cut carefully: you need it to be dead straight and true, because any bend or kink will be sure to make it pretty useless.

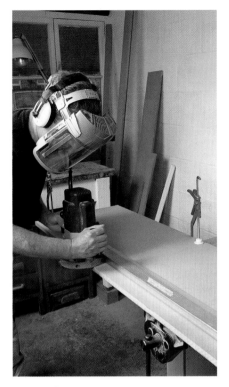

FIG 5.12 The author using a plasterer's featheredge. The strip of tape is marked with a reminder of the offset required when using a standard straight cutter.

The featheredge

Alternatively, you can use a 'plasterer's featheredge'. This is made of extruded aluminium and has a tapered edge which is handy for drawing out the size and shape of the piece you wish to cut. The other edge is vertical and it is this one which we run the router against to make the cut. The featheredge comes in different lengths. I have found the 2.4m (8ft) version to be the most useful, because it matches standard manufactured board sizes, thus making the cutting and moulding of ply, chipboard and MDF quite easy (see Fig 5.12).

FIG 5.13 A straightedge with the offset measurement marked on to it.

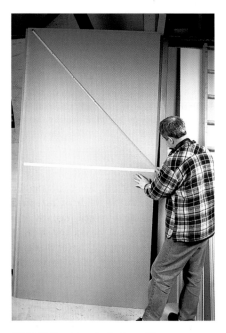

FIG 5.14 Checking that a board is square. Masking tape has been used here to emphasize the pencil line.

Using a straightedge

The technique for using any straightedge involves working out the distance between the edge of the cutter and the flat 'running' edge of the router base. Once you know this (and it varies according to the cutter that you have fitted), it is then easy to mark that distance back from the original size which you have marked out on the board (see Fig 5.13). If you choose to make your own straightedge from a strip of board, you could fit a couple of handles on to it to make it easy to pick up. You could also mark on to it the offset measurements relating to the cutters you intend to use. If you stick to just one cutter diameter, of course, you won't get into a muddle.

Clamp the strip down in the correct position and run the router along it till the cut is done. To clamp the straightedge, it is useful to have a quick one-handed method of holding the straightedge on the work. I have found that Solo clamps, sometimes known as 'mastic gun' clamps because of their design, are excellent for locking a straightedge in place quickly. G-cramps, which take a bit longer to tighten or loosen, are more dependable.

This is an accurate way of working, especially when you get used to measuring the distance between the cutter and the edge of the router base. Care is needed when pulling the router along the straightedge towards you, because over a long distance it is easy for the router to wander off course. If you ensure that you are cutting into the waste piece, that isn't such a worry. Using this method it is possible to do lots of cuts anywhere on a board.

Generally, manufactured boards are sawn square, and this makes crosscutting easier. However, you can verify that a board is square by measuring and marking a square, starting at one board end and spanning the entire width. Once this is done, measure

accurately across the diagonals and the readings should be identical (see Fig 5.14). If they aren't, then adjust your crosscut marking out accordingly.

Guide rails

Some router manufacturers have devised their own guide rail systems which are better and more expensive than the methods previously described. Guide rails come in sections (often about 1.2m [4ft] long) which can be joined together to make longer rails. Festool and DeWalt are just two of the companies that use this system. There is a small step in the aluminium extrusion that forms the rail. An adapter fits on to the fence rails and sits over this step. This keeps the router running true from one end of the rail to the other.

This system is also shared with other tools in the manufacturer's range, such as circular saws, and gives reliable results in the workshop or on site (see Fig 5.15).

ROLLER GUIDES

There are occasions when a normal fence or a bearing-guided cutter cannot be used. An example might be a table base with lots of curves which needs a top to match that will overhang by the same amount all round. Shaping such a top without a template would be a problem. In practice, you need to remove most of the waste first, leaving just about 2–3mm ($1/16$–$1/8$in) to be trimmed off (see Fig 5.16).

To complete the final shaping you then need to fit a roller guide to your router. The roller follows an existing surface so that the cutter follows the same path. It is mounted on to an adjustable guide assembly which hangs down below the base of the router. The roller is often fitted to the fence on cheaper models, though on professional machines it may have a separate means of

attachment. The roller guide can be moved up and down and towards or away from the cutter axis.

As with all router operations, it is as well to make a test cut on spare material after you have set the roller. This is because, however careful you are, it is difficult to get any setting absolutely spot on. It is never a good idea to do a test cut on your actual workpiece, because it is easy to take too much material away. In this instance we are shaping a top on a table overhanging by say 10mm ($3/8$in). The

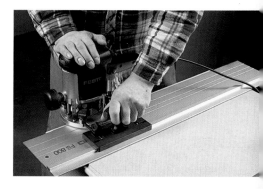

FIG 5.15 A Festool guide rail in use.

FIG 5.16 A roller guide in use.

roller needs to be positioned 10mm (³⁄₈in) closer to the table than the cutter itself. It is sensible to raise the roller so that it is as close to the table top as possible, thus ensuring that the top follows the table shape. Any lower and there may be a variation, especially if the base is flared in shape.

When following a shape with a roller guide, it is important to keep the guide bracket at 90° to the face of the workpiece. Unlike an ordinary fence, there is nothing to stop the router swinging about the axis of the roller and give a rather irregular cut that doesn't exactly mirror that of the original workpiece. Basically that is all there is to this gadget. You won't need it a lot, but it is very handy to have one when you do.

ROUTER CARVING

The router may not seem a natural replacement for what is essentially a hand skill, but it does have its uses even in this area. For small work (when you want to add some detail to an otherwise plain piece of work, for instance) you can try using a router. Experiment on a scrap piece first.

Use only the tip of a V cutter or a straight cutter with a very small diameter: larger cutters or passes will be erratic and tend to move the router in unexpected directions. Mark out a simple design, set the required plunge depth and go to work. You need patience and the ability to follow a line carefully. As the scale of work is so small, it may be better (and quite safe) to hold the

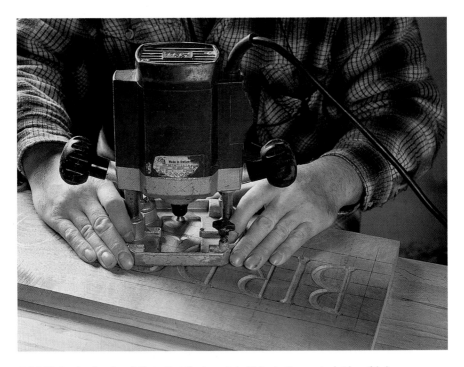

FIG 5.17 Carving freehand. Note that the base is held for better control. Also, this is an exception to the no 'backfeeding' rule. The point contact allows the operator 'kickback free' fine machining.

edge of the router base instead of the handles, gently pushing it back and forth, working along each line until you achieve a neat result (see Fig 5.17).

TRIMMING LAMINATES AND PROFILES

Nowadays, in the age of the post-formed kitchen worktop, it isn't quite so necessary to use stick-on laminates that subsequently need trimming. The main uses for laminates today tend to be the domain of the professional woodworker: shopfitting, reception and airport check-in areas, bank counters and caravan interiors. Nevertheless, there are still times when laminate and contact adhesive are the only solution to a problem. At other times, you may find yourself with veneered boards and other materials that require neat trimming. A range of trimmers is available. There are also straight trimmers for flushing off the solid lippings that are added to the edges of carcasses and worktops.

There is little to using these cutters. The main thing is to avoid trying to trim off too much waste material in the first place. No matter how thick the material, it should not project more than about 3mm ($\frac{1}{8}$in) (see Fig 5.18). More than this and the cutter will find it hard to cope. The material, whether solid wood or laminate, can break up and actually leave a ragged edge even after the cutter has trimmed the material flush.

If a bearing-guided trimmer is used, then the bearing just runs against the finished edge of the board while the blade cuts the projecting laminate off. There are bevel trimmers which do a little more than that. They will put a tiny bevel on the top edge, or the bottom as well in the case of a twin-bladed type. This is often better than a straight trimmer, because a dead square edge to a worktop is uncomfortable to the touch (see Fig 5.19).

FIG 5.18 Machining an acceptable amount of laminate overhang.

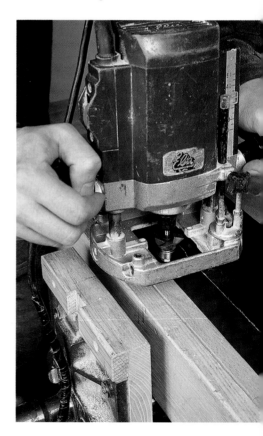

FIG 5.19 Bevel trimming in progress.

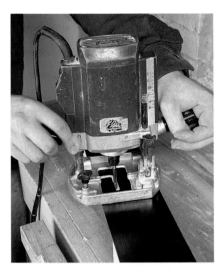

FIG 5.20 Through pierce and trim work showing fixed pilot.

FIG 5.21 Flush trimming with skis.

If you need to trim an inside shape, such as a hole in a worktop to take a sink, then the pencil-slim 'pierce and trim cutter' is a neat answer. This uses the shank top and bottom as a pilot and it can work right into an internal corner (see Fig 5.20). It comes in single- or two-bladed types for trimming, either on the top alone or on the underside

at the same time. At the bottom it has a cutter to help it pierce the laminate sheet.

Lastly, the flat, bottom-type trimmer is ideal for flush trimming solid strips inlaid into a larger surface, or for cleaning up background areas when doing relief carving. In both cases you would need to use 'skis' (see Fig 5.21). These are made for several types of well-known router, but it is possible to make your own. What the skis do is to lift the router so that the base can pass over any wood that stands proud of the surface. The skis slide on a level surface either side of the working area. The cutter needs to be carefully adjusted downwards until it neatly skims the surface. The correct type of cutter has three blade 'wings' and bevelled or rounded corners to stop it digging in. Ideally a fine depth-adjuster needs to be fitted to the router for precision setting, although cheap models do not accept one.

The laminate trimmer

Although it sounds like a cutter, this is in fact a small router for trimming. It will accept most small cutters and will take a roller guide and possibly even a small straight fence (see Fig 5.22). It is a fairly compact machine, usually tall and slim in shape with 550–600watts of power. If a lot of small edge work is required this may be a suitable solution. My own experience has been that my MOF 96 router has coped just as well with trimming edges, and also with working overhead and into corners. The laminate trimmer is not a proper substitute for a small router, but it is undoubtedly useful to have in certain circumstances.

USING CUTTERS FOR FREEHAND WORK

Some cutters look so large and fearsome that using them for freehand work just doesn't feel right, but there must be a more rational

FIG 5.22 Using a laminate trimmer.

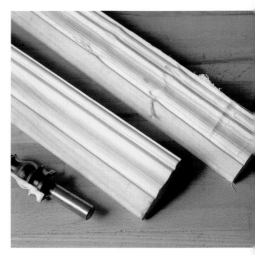

FIG 5.23 Above: difficult moulding tackled freehand. Below: the same moulding done on a table.

way of deciding what is safe and wise to use. Catalogues usually give excellent guidance on which cutters must be used in a router table rather than freehand. Most cutter manufacturers and suppliers mark those that shouldn't be used freehand with a warning statement and sometimes a symbol, too. The ones you shouldn't use in this way tend to be the largest sizes, because the sheer mass of spinning metal and the force involved when they strike the wood makes them much more dangerous than smaller versions of the same cutter.

A glance at the catalogues shows straightaway that most cutters can be used freehand, even if it isn't always a good idea. The dangerous cutters are mainly the ones with complicated moulding profiles. If the router moves around during the cutting, they can damage the wood badly.

As a beginner, with a small router capable of using just ¼in shanked cutters, the choice is made for you, because cutters of this size are not big enough to be a risk. Perhaps what is more important is not whether you should be doing everything freehand, but whether it wouldn't in fact be better to use a table. The router table offers much more control and greater safety. With hold-downs and a better view of the work, it is possible to achieve a much better and more precise finish (see Fig 5.23).

All basic operations with straight cutters and simple moulding shapes, like the roundover, cove or chamfer cutter, work well freehand. More complicated shapes, especially when they are built up cut after cut, need to be used in conjunction with a table. See Chapter 7 for more information on using router tables.

6

Jigs and templates

HERE WE LOOK at making and using jigs and templates. Both bearing-guided and ordinary cutters can be used, depending on the work that is planned.

Technically, a jig is a device that locates parts and the machine, in order to make accurate and repetitious operations possible. Examples would be machining cutouts for hinges and mortising table legs (see Fig 6.1). In these cases, existing components have to be held and located precisely so that the machining is accurate and all components will match. Jigs are usually made from something hard and dense such as MDF or Tufnol, and they can be used over and over again.

A template is similar. It can be made of MDF or plywood and can be used to create a specific shape, such as the swept shape of a rear chair leg or the outline, windows and doors of a dolls' house. In this case, though, the material is unshaped except in thickness, and machining it will confer a proper shape upon it (see Fig 6.2).

USING JIGS AND TEMPLATES

You would usually start by creating a shape with a template and then machine any specific areas on that shape with a jig.

For any jig or template to work, you need some means of guiding the router and therefore the cutter. Bearing-guided cutters can be used, although it is customary to use guide bushes fitted to the base of the router.

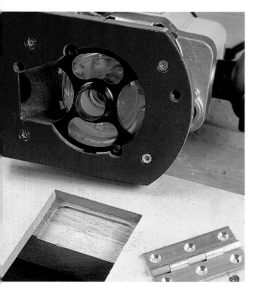

FIG 6.1 A typical hinge jig.

FIG 6.2 The front of a dolls' house.

The guide bush will be larger than the cutter, so you need to calculate the difference between the two before marking out a jig – the holes will need to be bigger than the actual finished size (see Fig 6.3). Expensive machines take guide bushes in different sizes, enabling the operator to use a variety of cutter sizes. Here are a number of templates and jigs that may be useful.

A TEMPLATE FOR A NAME PLAQUE

Let's start by making a template for a house name plaque. It will have a bevelled profile. The plaque is rectangular and could be cut on a table saw or with a jigsaw and then cleaned up with the template and cutter (see Fig 6.4). Note that this operation needs to done in the router table.

Method

1 Cut out the template accurately with the router. Ensure that you make a proper rectangular shape by using a set square. Cramp on a straightedge in order to make a nice neat cut with a straight cutter. As the template is only 6–9mm ($^1/_4$–$^3/_8$in) thick MDF, this can be done in just a couple of passes. Repeat this 'cut through' operation until you have done all four sides and the template drops out of the board.

2 Pin the template to the reverse of the workpiece (see Fig 6.5), which should be 2–3mm ($^1/_8$in) bigger all round. Fit the router in the table and use a straight cutter with a bottom-mounted bearing (actually at the top when the router is inverted). Wind it up through the hole until the workpiece and template are next to the cutter. Adjust the router height until the bearing is against the template (which is on top) and the cutter likewise, just a fraction (see Fig 6.6). Note that a Perspex guard should be fitted

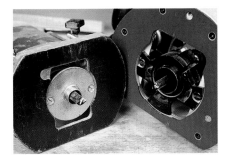

FIG 6.3 Guide bushes fitted to a small and a large router.

FIG 6.4 The finished house name plaque, letters emphasized with black lacquer.

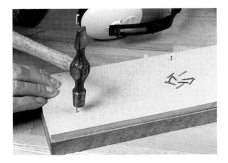

FIG 6.5 Pinning the name plaque template to the slightly larger workpiece.

over the cutter. You will also need a 'lead-in' point (see Fig 6.7) to support the work safely as it approaches the spinning cutter - not to do so will result in an alarming

FIG 6.6 The cutter is higher than the workpiece, but the bearing still runs properly against the template.

FIG 6.8 Working the short grain over the cutter, Perspex guard, lead-in point and extraction pipe in place.

FIG 6.7 Using a lead-in point and a Perspex guard over the cutter for shaped work.

'kickback' as the workpiece catches the cutter and is chucked aside.

3 Start the cut along one long grain edge, to gain confidence. The wood goes to the left of the cutter, in front of it and against the rotation of the cutter. Push at a firm, even rate and, by carefully changing your grip, continue the cut all round the edges. Having done this exercise once and got used to this kind of machining, you should make a habit of doing the crossgrain passes first (see Fig 6.8). The reason is that 'tearout' may occur and you need some excess material on the 'long grain' edges so that any torn wood can be machined away when you make the 'long grain' passes.

4 You should now have a neat rectangular piece of wood that needs a bevel to complete it. To do this, fit a chamfer cutter in the router and remove the template from the wood. Raise the cutter till the bearing runs along the last third of the edge of the workpiece (see Fig 6.9). Now start cutting as before and run all around the edge. The result should be a neat bevel effect on what will be the outer face of the name plaque.

5 You can now add ready-made letters to this name plaque or try your hand at router carving with a V-point cutter (see Chapter 5). Obviously you can vary the amount of bevel by raising or lowering the cutter, as long as the bearing is still in contact with the workpiece. Rather more complex and irregular shapes can be created and, as long as the template is well made, the cutter must follow it.

FIG 6.9 The chamfer cutter set against the workpiece.

FIG 6.10 A completed dolls' house.

TEMPLATES FOR FREEHAND WORK

Dolls' House

It is possible to combine a jig and a template on one piece of work. A good example is the front panel of a dolls' house. This has both an outline which requires a template and various window and door piercings which need a jig. Dolls' houses are popular, and making them can be interesting (see Fig 6.10) – it's an easy thing to do with a router and a bit of common sense.

Method

1 Draw the shape on to the thin board which will be used as the template. Get the outline shape right and add the windows and door (see Fig 6.11).

2 Choose a cutter and the guide bush that matches it. A cutter with a reasonably

FIG 6.11 The dolls' house template/rod with all data added.

small diameter is sensible, because it will leave the corners of windows and so on with just a small rounded shape. For neat, fairly square corners a 6.4mm-diameter cutter is best. Measure the difference in both external diameters (vernier callipers are useful here) and work out the difference. Let's suppose the guide bush is 17mm (1¹/₁₆in) diameter and the cutter is 6.4mm (¼in). Subtracting

FIG 6.12 A close-up of the template showing the guide bush allowances marked on it.

FIG 6.13 A close-up of the window and door apertures. A predictably neat result.

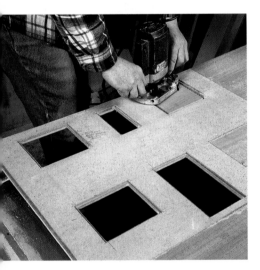

FIG 6.14 Routing underway, with the template fixed to the work. Each panel can be produced very quickly.

6.4 (¼) from 17 (1¹⁄₁₆) gives you 10.6 (⁷⁄₁₆). Dividing this by two, because the difference is split between both sides of the cutter, will give you 5.3 (³⁄₁₆). Now mark back from your existing drawn lines by 5.3mm (³⁄₁₆), thus making all openings larger and the outline smaller all round (see Fig 6.12).

3 Take your router, minus the guide bush, and use the 6.4mm (¼in) cutter and a clamped-on straightedge to shape the template following the new set of lines. This will take a little while, and care is needed to avoid overrunning at the start and finish of each cut where they meet at the corners (see Fig 6.13). Use some panel pins to fix the template to the intended workpiece (see Fig 6.14). This might seem like lot of effort, but if you want to produce even limited quantities of the same design, then this is the way to do it.

Having machined the front panel, the sides and back present no problem. Often the back is just plain, so it may be practical to use the front template but miss out the windows and door. The ends, or sides, of the house could be identical. This repetition work can be applied to other parts of a dolls' house, such as stairwells and internal walls, roof shapes and chimneys.

WORKTOP JOINTING

Building and fitting a new kitchen is a pretty common activity, and jigs and templates are natural for this kind of work. I'll start with worktop jointing. The standard type of kitchen worktop is postformed laminate with a 30–40mm (1¼–1½in) chipboard core. There are other materials of course, such as solid hardwood, granite and Corian, which is an expensive man-made worksurface material. Post-formed laminate has a rounded front edge which means that any joint other than in a straight run needs to be a special offset joint like a dogleg. Professional kitchen fitters use special Tufnol or aluminium jigs. These make both halves of the joint and the recesses underneath which take the special worktop bolts that pull the joint together (see Fig 6.15). Not surprisingly, such a jig is expensive, being upwards of £160 plus VAT, so for the occasional user there must be a simpler answer.

FIG 6.15 A Trend Combi 650 postform jig.

Method

1 Good old MDF is cheap and ideal for this job. In fact, if you are going to be a serious router user it's a good idea to keep some in stock at all times. You will need 6–12mm (¼–½in) thick MDF for jigs and templates, with thicker board for actual projects. Accurate drawing is necessary, so use a long steel rule and a sharp pencil to mark out your jig on some 9.5mm (⅜in) MDF (see Fig 6.16). This one-part jig is for use with a guide bush and requires a big router. The thickness of cut and the stress imposed on a 1/4in router and cutter would be too much and the cutters available are just too short. The small openings are for worktop bolt recesses and they are done after the joint is cut.

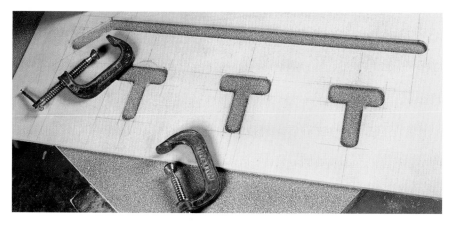

FIG 6.16 A home-made kitchen worktop jig, in MDF.

2 To use the jig, push it against the worktop so that it lines up against the worktop edge. Note that one half of the joint is done from above and the other from below, the reason being that the cutter must always start at the front edge of the worktop. If you were to cut from the back towards the front, the laminate would rip off the front edge and ruin it – so one pass must be done with the worktop inverted.

3 Fix a 25 x 50mm (2 x 1in) batten all round the walls at the height of the units which should have been levelled already. This batten will carry the back edge of the worktop. It will be fixed to the batten with angled steel plates or nylon blocks. When fitting the worktop, ensure that you have enough to do the job.

4 Decide where the joints should be. This may be dictated by the position of appliances or walls. Mark and cut your first section to fit between walls, etc. Try to arrange things so that you do the joint half that is recessed into the front edge of a worktop first. Then sit that half of the joint on top of the other worktop section in situ and mark along the edge of the joint on to the uncut worktop. This should give an accurate line for the second cut. Now fit the jig again (see Fig 6.18) and cut (in a number of passes) to the full depth, put the resulting joint together and check the fit.

5 Make the rest of the connecting joints and then the bolt recesses (see Fig 6.19). These allow the bolts to fit neatly so that they can be tightened with a spanner.

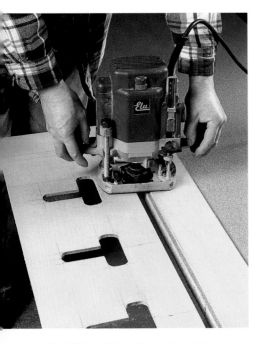

FIG 6.18 Machining the postform joint recess, using several passes.

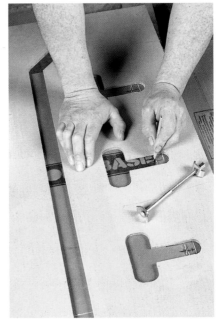

FIG 6.19 Marking the bolt positions across both sections of the worktop.

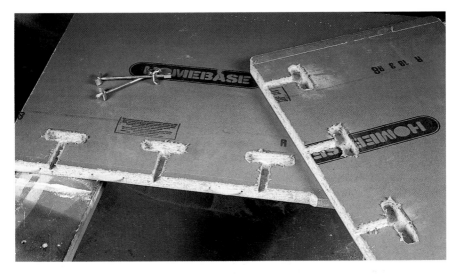

FIG 6.20 The joint edge showing the biscuit slots, and the bolt recesses.

6 Use an arbor and groover to biscuit joint the edge (see Fig 6.20 and slotters in Chapter 4). This prevents any warping or misalignment between worktop sections. The postform joint can be used with hardwood worktops, although the amount of 'dogleg' can be reduced, because any roundover on the edge is normally much smaller than that on laminate tops.

PRECISION DRILLING

Within its own capacity the router is better than any conventional drill. This aspect of the router has not perhaps been exploited much by cutter manufacturers, except on full industrial machinery. What makes it so good is its ability to drill straight and true every time (see Fig 6.21). It is sometimes very difficult to aim a powerdrill straight unless it is mounted in a stand. Also, drill bits tend to wander and chip the surrounding surface unless they are proper bradpoint drill bits or the Black & Decker 'Bullet' bits. Drill bits for the router come in a limited number of

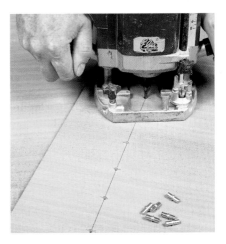

FIG 6.21 Using the router to drill stud holes for shelves.

sizes and they often double as countersinks or counter-bores. They are extremely useful and make accurate repetitious work possible (see Fig 6.22). For limited use, and for shallow drillings, it is possible to use ordinary straight router bits such as the 5mm ($^3/_{16}$) size

FIG 6.22 From left to right: a counterbore cutter, its matching plug cutter, and two router drills.

FIG 6.23 A router with crosshair sights.

FIG 6.24 Hinge and shelf stud jigs for kitchen cabinet fittings. Note that the hinge is done with a small cutter and guide bush to give a hole with a large diameter.

for shelf studs etc. The disadvantage is that they heat up and collect resin, although each hole is drilled so quickly that this isn't too much of a problem.

To take advantage of this facility, you need to do one of two things. First, you can mark up a piece of thin clear plastic with cross hairs, such as are found in a telescopic sight of a rifle. Attach that to the base of the router with double-sided tape, then plunge the cutter through the plastic and you are ready to drill (see Fig 6.23). You can stick some abrasive paper to the base (not over the visible plastic) to act as a grip. The router will then stay put while it drills the hole.

The other method is to make a purpose-built jig which accepts a guide bush where each hole is to be drilled. This would be suitable for things like a series of cabinet shelf supports, or for mounting hinges on the carcass of a kitchen cabinet. This will be more precise than the first method but may do only one sort of job.

Each jig will have to be made to suit your own circumstances, although certain components, of course, don't change in size. Kitchen hinges need a 35mm ($1^3/8$in) hole, while shelf studs need a 5mm ($^3/16$in) hole (see Fig 6.24).

However, the type of hinge and backing plate – these can be separate and of different thicknesses – will determine the exact positioning. The thickness of the carcass also affects this, as does whether a hinge is on an outer panel or a centre panel. In the latter, a slightly cranked hinge is needed.

FIG 6.25 A hinge jig.

LOCK AND HINGE JIGS

First, a simple hinge jig. You can decide what size of hinge you wish to fit. Whether it is a large hinge for the door to a room or a much smaller one for a cabinet, the principle remains the same (see Fig 6.25).

To make small jigs like this you can use a router, straight cutter and fence to cut out the shape for the guide bush to follow. Inevitably, with a small jig there may be some tidying up to do, so one or two round and flat files are handy for neatening the internal edges. Because the guide bush is round anyway, rounded corners on the jig are not a problem as long as the corners of the jig have the same or smaller radii than that of the guide bush. Once made, such a simple jig can be used time and again. Several of these jigs will cater for all the usual sizes and give a neat and predictable result. A key feature is leaving enough of a 'wing' at each end so that the jig can be clamped in place, and enough running surface on top so that the router sits properly (see Fig 6.26). You also need a

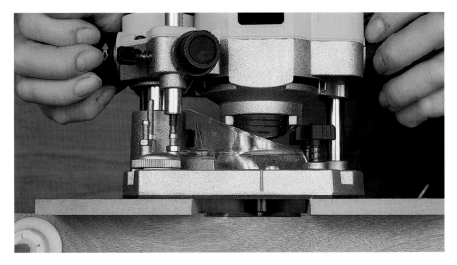

FIG 6.26 Using the router with the hinge jig in place.

location mark so that the jig will always be accurately positioned no matter where the hinge is to be placed. The sensible place is in the centre of the jig, this being also the centre of the hinge (see Fig 6.27). An alternative is to make the jig exactly symmetrical so that you can set it to a line using the end of the jig.

Whatever you do, make sure that the guide marks are made on the doors and carcass by striking the pencil across both at the same time. The result are marks that can be relied on to be accurate when using the jig. If you attempt to mark the components separately and away from each other by just using a rule, you are guaranteed to have hinges that will not line up, thus ruining the whole idea of the jig. In order to set the correct cut depth for the hinge, a little experimentation is necessary.

If you are setting one half of the hinge into the frame and the other half into the door, then start by placing the narrowest part of the opened hinge under the depth stop rod of the router with the cutter at rest on the workpiece. Then lower the rod and trap the hinge at its thinnest point between the rod and the revolving turret. Lock the depth stop, thus giving a set depth for each half of the hinge 'joint'. Another way is to fit the hinge to the door only, in which case you put a closed hinge under the depth stop rod (see Fig 6.28).

Obviously, the fit of the door in the frame affects the tightness of the fit on the opposite side to the hinge – it might leave a big gap or nothing at all. Don't set the hinges in too deep. It isn't necessary, and it will pull the door tight against the frame so that it won't shut properly. The only way to deal with this if it arises is to fit some packing under the hinge (paper or bits of veneer, for instance) in order to push the door away from the frame.

FIG 6.27 The hinge jig showing the centre-alignment mark.

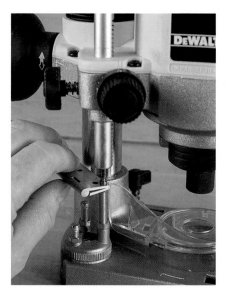

FIG 6.28 The hinge trapped under the depth rod at its thinnest part.

FIG 6.29 The cabinet lock set in. A chisel is needed to square out the corners of the recess cut by the router.

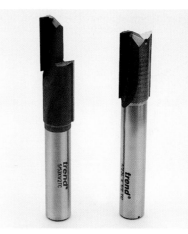

FIG 6.30 Stagger tooth and pocket cutters. When deep mortising, the extended shank on the pocket cutter enters the hole.

LOCK MORTISES

Cutting lock mortises by machine is a lot easier with a router than it is by hand, and much quicker. Jigs for such a job could range from one designed to set in a shallow cabinet door lock, which fits on the reverse of a door (see Fig 6.29), to the more typical situation of a lock for a standard room door. The latter stretches the router to its limit in terms of cutter capacity. It needs a $\frac{1}{2}$in router for a start and a very long, strong, straight cutter especially designed for this kind of operation. Not only does the cutter need to plunge deep in order to make an adequate mortise, but it also needs to be able to clear away a lot of coarse chippings to prevent the socket becoming too congested. If this happens the cutting rate will slow down and the cutter will overheat.

Currently, the maximum cutter size for this application has a cutting edge about 50mm long and a diameter of 16mm with a 'staggered tooth' or blade configuration (see Fig 6.30). By careful adjustment of the amount of shank in the collet, it is possible to obtain a cut depth of 70mm ($2\frac{3}{4}$in) which will cover shallower mortise lock applications. Deeper sockets will need to be cleared by chisel and mallet to the right depth (see Fig 6.31).

FIG 6.31 Deepening the hole with a chisel.

FIG 6.32 Making a trial cut for the lock face, using a jig. A separate jig will be needed to cut the deep mortise.

To carry out lock mortising, it is possible to use a router with two fences fitted on one set of rods. The disadvantage is that the router waggles about on the edge of the door and can't cut an accurate socket parallel to the front and back surfaces of it. It is better to make a jig that sits on the door and can be clamped in place (see Fig 6.32).

As with the hinge jig, make a centre mark that will line up to a pencil mark on the door. Use a guide bush as before, and set it so that it does not project through the thickness of the jig material. Although the jig is just 6mm

(¼in) thick, it will reduce the possible plunge depth by that amount. A stagger tooth cutter will give you a bumpy ride, but a quick one. Technically, this isn't a plunge-type cutter, because it doesn't have a bottom-cutting part. However, my own experience is that you can make a series of gradual sloping cuts (known as 'ramping') down to the final depth and then lock the router at full depth and run round in order to smooth the sides of the hole. Note that you will need to make each pass in a clockwise direction, so that the cutter is slicing into the wood.

Having made the mortise with the router, it is usually necessary to square up the corners with a chisel for the lock to fit properly. This isn't the end of the story of course, because after this has been done you still have to make a recess for the faceplate and holes for the handle shaft and key.

It is best to make a second jig for the faceplate recessing which allows the recess to be done in one shallow pass, while the corners are squared out with a chisel. You need to make a centre mark that can be lined up with the original centre mark on the door, thus matching the first jig position exactly. The side hole borings can be done in one of two ways. The first method is to add a piece of 6mm ($^1/_4$in) MDF to the side of the second jig with small holes drilled into it.

You can mark the door by pushing a bradawl through these holes, and then drill freehand. Alternatively, you can make holes in the MDF to take a small guide bush and an even smaller cutter with necessary allowances made for the cutter-to-guide bush diameter, as is usual when doing this type of operation (see Fig 6.33). The small, straight cutter can then produce the rather neat little holes that are required.

It's hard to justify all this effort for just one lock, but the result is satisfying and part of an important learning curve. If you are fitting several locks it begins to makes sense, because they can be done very quickly. This

FIG 6.33 A jig for the handle-bar and keyway.

is the beauty of jigs and templates – predictable and reliable results every time.

The intelligent use of jigs and templates can speed up the production of standard parts, increase accuracy and simplify operations. If you are planning a major project they will make your life a lot easier.

7

Inverted routing

IT IS EASY to think of the router first and foremost as a portable handheld tool. It is, but a bit of experience shows that this method of working has many shortcomings and it is easy to blame oneself, as the operator, for these. Poor visibility, lack of proper control on small or narrow work-pieces, inexplicable inaccuracies between supposedly identical components and the inability to undertake difficult operations are only some of the results of working freehand. Freehand is fine, of course, for the right kind of operation, but there are limits. Like a lot of professionals, I use both a ¼in router and a ½in model, and the bigger machine spends most of its time upside-down under a table.

This is because I regard it more as a router spindle, like a small spindle moulder.

The router spindle, with the plethora of cutters available, from small to extraordinarily large, can now challenge its bigger static cousin, the spindle moulder. It's not quite that simple of course, but even a small router and a modest table will give neat and controlled results, including 'stopped' operations in which the cut must have a precise beginning and end. Joint cutting is also practical in situations where doing it any other way will result in ill-fitting results.

PROPRIETARY ROUTER TABLES

Project Chapters 13 and 14 give ideas for building your own router table. For now, though, we shall look at a variety of tables on the market today. These vary from very lightweight plastic to more substantial cast alloy and pressed steel. The old adage that 'you get what you pay for' applies here. If you've bought a machine like the Bosch POF 600ACE, which is a well-made machine with a decent motor rating, don't treat it badly by matching it with a poor table. Spend the extra to get a good table that will last and prove its worth.

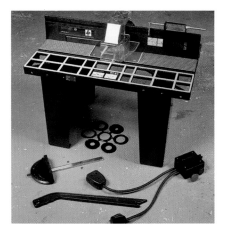

FIG 7.1 A Bosch router table and all of its accessories.

Look for the following items in a table:
- a large, flat, solid work surface
- a rigid, accurate fence with plenty of space in the opening for large cutters
- proper, effective hold-downs

- a means of fitting extraction
- a safety-type switch (known as an NVR: No Volt Release) to override the router's own switch
- a mitre fence
- some form of guard over an exposed cutter
- extras such as a roller bearing guide for unfenced work and a 'lead-in' point for safe machining the same work
- some means of securing the table, so preventing it from slipping around

Not surprisingly perhaps, all these things don't arrive as standard, and if they are available they are often extras which add to the cost (see Fig 7.1).

Many tables are not very large. This is fine for some kinds of work, but long workpieces present a problem. This can be overcome with roller stands if the wood is fairly straight and true (see Fig 7.2). Explore what is available by using catalogues, shops and the opinions of those who should know how, and never pass up an opportunity to look at the goods first-hand.

It's admirable to think of making a table instead, but bear in mind that a ready-made table should have solved all the construction

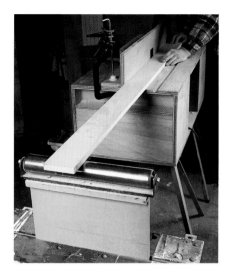

FIG 7.2 A roller stand makes work easier and safer.

problems. This is a definite advantage for the first timer.

The table set-up

Let's look in detail at each part of the table set-up and some examples (see Figs 7.3a, b, c, d, e). The table itself should be cast aluminium, pressed steel or a piece of MDF

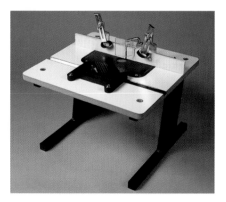

FIG 7.3a The Charnwood W002 table.

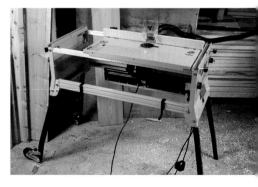

FIG 7.3b The Triton workcentre with the optional router table fitted.

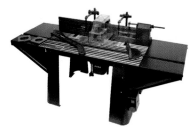

FIG 7.3c The Trend Craftsman router table.

FIG 7.3d Dewalt DW2000 table.

on a metal frame. Some tables are ribbed (see Fig 7.4) to reduce friction on the work and to give the wood dust somewhere to go. Usually, there is a slot running the full length which is used to hold the mitre fence, and this may have a dovetail profile for precise running. This fence allows you to machine the ends of components at 90° (or other angles down to 45°) to the fence. To do this, you slide the mitre fence forward, pushing the wood towards the cutter and past it until the cut is done. It is possible to use an accurately cut block of wood as a substitute for the mitre fence when doing 90° work.

The table's main fence should be the length of the table, with two separate faces and a reasonable-sized gap in the middle where the cutter will be. The fence faces should be capable of accepting wooden facings or one long through-fence which covers the cutter completely. This is good to have when you need maximum work support, especially when machining short ends.

To make a through-fence, switch on the router with the fence in front of the cutter. Then pull the fence back until the cutter

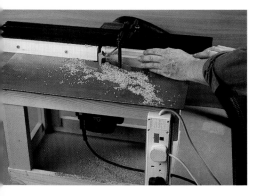

FIG 7.3e A Veritas rolled steel table with an extruded fence and an extraction spout fixed to the table with magnets. A table like this isn't cheap but it will last a lifetime. A variety of extras is available.

FIG 7.4 A ribbed and skeletal table surface allows the workpiece to move unhindered by dust.

FIG 7.5 A minimal hole made in the subfence for cutting skirting. This gives an unwavering finish. The same principle applies when cutting short workpieces.

FIG 7.7 The extraction port on the Veritas fence. It has a removable reducer for attaching small-bore hose.

FIG 7.6 Checking the flatness of a fence (with subfences fitted).

Holding the work

It is essential that there is some proper way of holding the work while you push it over the table. This will ensure that the wood is evenly and accurately shaped by the cutter. You can then concentrate on pushing the work through at an even rate. Work that does not get this kind of pressure tends to be unevenly shaped or moulded, and it will have chattermarks which have been caused by running loose over the cutter.

Safety is improved too, because the work is held by the machine and not the operator, except for long lengths which do need additional support. The operator's fingers, which are vulnerable, can be protected

'breaks through', showing just the right amount of cutting surface to do the intended work (see Fig 7.5). Both of the basic machined surfaces of the fence should be 'true' to each other, and a steel rule placed across both will show just how flat they really are (see Fig 7.6). The centre part for the cutter must give full enclosure to the cutter except the front face, and it must also have some kind of extraction port to take a hose to a light industrial vacuum cleaner (see Fig 7.7). Extraction is essential. A cast-off ordinary vacuum may have enough suction but is unlikely to have sufficient dust capacity, and no machine normally used for domestic cleaning must ever be borrowed for this work. (See Fig 7.8.)

FIG 7.8 The WAP 700A lightweight extractor with auto switching.

FIG 7.9 An adjustable sprung Shaw guard.

by guards that physically obstruct most approaches to the cutter.

Generally, there are two sorts of hold-down. One is the 'Shaw guard', which consists of a sprung, wood-faced pad pressing on to the workpiece (see Fig 7.9). It can be adjusted to give optimum pressure, and two of them are required for proper support: one vertically and the other horizontally. The other type is the 'sprung finger' type, which consists of many diagonal thin tines or fingers pressing against the workpiece. They are fitted so that they lie angled in the direction in which the work is fed, and they bend a little as the work is forced against them (see Fig 7.10). They can be made from plastic, or home-made from MDF, and once again two are required. There are other kinds of hold-down, but they all do the same job and the fence should be fixed firmly enough to resist any pressure exerted on the workpiece by the hold-downs.

FIG 7.10 Holding the workpiece with spring fingers.

THE ROUTER SPINDLE

Edge moulding

The first, and most common, operation you are likely to do on the table is edge moulding. You take a square or rectangular section of wood and cut a moulding into it. (Note that the wood must first be square.)

FIG 7.11 Checking the squareness of softwood with an engineer's square.

FIG 7.12 Waney edge board being marked up for cutting. A saw table and a planer are required.

FIG 7.14 Sawing a moulding from a board. A new moulding can then be made.

FIG 7.13 A lightweight planer, being used here in its thicknessing mode to reduce stock to an exact size.

take a wide board, mould the edge and then cut that moulding off – with a circular saw in a table – repeating the process as many times as necessary (see Fig 7.14). This not only makes more efficient use of the wood, but the quality of the moulding will be better because a small section will vibrate much more as it passes over the cutter, and with a deep pass it may even break up into pieces if the wood has any defects such as short, angled grain or knots.

With a wide board only the top hold-down can be used, because the table won't be wide enough to fit the other one. Apply side pressure with your hand instead (see Fig 7.15). Many cutters, such as the ovolo and cove, have simple profiles, but some cut a

Softwoods from a timber yard or a DIY store are generally square when sold in prepared form, although a check with a try square or an engineer's square may reveal otherwise (see Fig 7.11). Hardwoods are not often sold in prepared form (see Fig 7.12) and, even if they are, may not stay straight and square. Access to a planer thicknesser is an asset to all woodworkers (see Fig 7.13).

If the wood is ready to use, it will run tightly to the fence and give a nice even-moulded finish. It is certainly quite possible to mould a small square section, but if you need a number of pieces it is much better to

FIG 7.15 A wide board held by hold-down and side hand pressure.

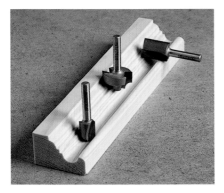

FIG 7.16 Multiple passes with different cutters allow a much more complex shape to be created. Note how the straight cut needs to be cut from a different position.

FIG 7.17 A workpiece with a 'stepped' end.

FIG 7.18 Using a spare piece of wood to align the rule when checking how far the cutter projects.

FIG 7.19 A workpiece leaving the cutter and about to slide on to a support on the outfeed part of the fence.

complicated shape in one pass. It is possible on the table to use one or more cutters, and to alter the height or the fence position so that a complicated shape can be built up in several passes (see Fig 7.16).

Building out the fence

A 'built-out' fence can be used for certain moulding operations. You may wish to mould the entire face of a component and in so doing make the work narrower. The result is that as you get towards the end of the workpiece it will start to dip in towards the fence and, at the very last moment as it passes over the cutter, the cutter will take a sudden 'step' or chunk out of the workpiece

as it drops entirely against the outfeed fence (see Fig 7.17). The answer is to fit a packing piece, of the same thickness as the intended cut, against this part of the fence. You can work out what thickness this needs to be by starting the cut, then stopping the machine and measuring the gap (see Fig 7.18). You can make this packing piece out of thin ply, MDF or even solid wood, and it can be pinned or screwed into the fence facing. As the work leaves the cutter, it will slide smoothly on to the added support (see Fig 7.19). Hold-downs should be used.

FIG 7.20 'Dropped on' working. Stop-blocks have been fitted to the fence to determine the length of the mortise.

'Drop on' machining

This technique requires nerve, because it involves slowly lowering a workpiece directly on to an exposed cutter while also pressing it against the fence. As a method for a beginner I cannot recommend it, but it does merit description because it is useful for certain types of work. Using a 'pocket cutter' one can perform mortising, providing that the fence is marked to show where to start and stop the cut and that the workpiece has datum marks as well. Stop blocks can also be fitted

for this and other stopped operations (see Fig 7.20). They act as a positive means of determining the end of a cut.

'Stopped' face moulding is also possible. This is where decorative detail is applied to the face of a workpiece, but needs to start and stop short of the ends. Obviously good control of the workpiece is necessary in order to make this kind of operation safe, and unfortunately this is where the problem arises. If the work is placed on and lifted off by finger grip only, it is quite possible to lose control. The cutter may 'grab' the workpiece and damage it (see Fig 7.21). The only way to avoid this is to fix some kind of work-holding device on to the workpiece which enables you to grip it and have the full control that is necessary (see Fig 7.22). It follows that most of the time this is not possible, because such devices will mark the surface of the wood with screw or pinholes. At no time must the fingers be exposed to the cutter. Shallow cuts are the only ones that should be attempted by inexperienced routers. This rules out 'drop on' mortising, but where

FIG 7.21 A damaged 'dropped on' workpiece. A gentle zig-zag downward movement is needed, as well as pressure against the fence. Note how the cutter has blackened – it was plunged too rapidly.

FIG 7.22 'Stopped' fluting with the aid of a fixed-on work-holding device. The sticky glove gives the operator a safer grip.

FIG 7.23 A picture frame with triple fluting. The corner blocks were fitted on afterwards.

FIG 7.24 An assembled profile and scribe joint.

FIG 7.25 The scribe part of a joint showing the grain.

In the old days, all door frame joints needed mortise and tenons to hold them together. The profile and scribe has rewritten the rules by using the decorative edge moulding, and the groove behind which holds the door panel, to form one half of the joint. The ends of the top and bottom rails make up the other half, having a matching 'scribe' shape (see Fig 7.24). The joint is tight and interlocking, and will set solid with a little PVA glue.

The term 'scribe' or 'scribing' is regularly used by woodworkers to describe any cut that is made which fits accurately to an existing surface, whether it is a piece of infill wood against a wall in a room or the 'counterprofile' in a joint. Where a joint is concerned, this is invariably done on the end grain or 'cross grain' of the wood (see Fig 7.25) and therefore a scribing cut is taken to mean a cross grain cut.

All scribing cuts done on the router table with any type of cutter need proper support behind the wood to prevent 'breakout' (see Fig 7.26).

There are about four or five different moulding patterns for profile and scribe jointing, including bevel, ogee, classical and ovolo (see Fig 7.27). They are available from a number of suppliers. They normally allow for a door 18–22mm ($^3/_4$–$^7/_8$in) thick with one or two larger sets for doors of 26mm (1in) thickness. These mouldings are ideal for lightweight doors in furniture. Large joinery-

face moulding detail is needed and the reverse side isn't seen, it is a good way of adding detail to a piece of furniture (see Fig 7.23).

Profile and scribe jointing

This is a modern jointing idea that has really taken off where cabinet doors are concerned.

FIG 7.26 Making a scribing cut with support behind. Note the special clamp and block behind the wood.

type doors can't be made this way, because they are twice the thickness, and consequently heavy, and subjected to a lot of stresses. More conventional techniques are employed on these. To complete profile and scribe doors, you need either thin, flat centre panels or a 'raised' solid wood panel (see Fig 7.28). The latter can be done with a panel-raising cutter which is available in a number of moulding styles and in both a normal and a vertical type. The vertical type fits easily into a small hole in a router table. These cutters can be used only with 8mm and ¹⁄₂in collets or larger, but it is preferable to use the ¹⁄₂in shank sizes, because of the stresses involved. The next chapter describes how to use them.

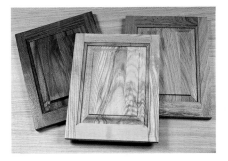

FIG 7.27 Frame and door samples: bevel, ogee and classical.

Bearing-guided trimming

This subject has already been covered in Chapter 5. The router table is ideal for work with bearing-guided cutters (see Fig 7.29).

Slotting and rebating

These are basic requirements and are easily done on the table, and with better control and finish than is possible freehand. As with

FIG 7.28 A raised panel and flat panel side by side.

FIG 7.29 Bearing-guided work on a router table, using a lead-in point.

FIG 7.31 A slot and rebate side by side.

FIG 7.32 Pushing work through with carefully placed fingers.

all table operations, make sure the work stays flat and slides easily along the fence. Next, set the cutter the correct distance from the fence. This can be difficult to check properly, because of the hole in the fence opposite the cutter – there is no proper way of using a rule to measure the distance. It is easier to set the distance roughly by eye and do a test cut (see Fig 7.30). Set the height as well, before machining. This applies whether you are cutting a slot or a rebate: a rebate is just half a slot after all (see Fig 7.31). When slotting, the cutter is fully exposed, but once the workpiece is pushed on to the cutter it becomes a temporary guard. Even so, you

should be careful about where you put your fingers when pushing the work through (see Fig 7.32). It is important to keep the wood tight against the fence, because it may wander a bit. With rebates, you are taking a corner out of the work, so you need to run the work squarely over the cutter without it

FIG 7.30 Test cuts on a spare piece to check cutting width.

FIG 7.33 Hold-downs and spring fingers for safety and good work control.

FIG 7.34 A tunnel produces a surprisingly chatter-free finish.

FIG 7.36 Using a straightedge to check for bowing.

FIG 7.35 Setting the cutter level with the outfeed with the aid of a rule.

dipping down. In this case, try using a vertical hold-down or sprung fingers placed over the area which isn't going to be machined (see Fig 7.33).

Another method is to make a 'tunnel'. This can be made accurately from ply or MDF. It needs an opening just big enough for the wood to pass through, and the longer it is the better. This tunnel needs to be fixed to the fence in some fashion (see Fig 7.34) and, providing the stock you are machining is accurately prepared, it is easy and quick to push it through the tunnel in safety and get a perfectly machined result at the other end. The tunnel method can be used for other moulding shapes

as well, unless you are intending to machine away the whole of one face. In this case, the resultant moulding will not have proper support (see the paragraph on edge moulding and built-out fences on pages 100-103).

Edge planing

Just as edge planing can be done freehand, so it can be done on the table, only better. Since the fence is quite long, it is just right for straightening edges. A router in a table cannot equal a full-sized planer and it doesn't give infinitely fine adjustment, but it is still very useful. With the professional spindle moulder, each fence can be adjusted separately: the outfeed fence can be positioned exactly to 'take off' the work as it is planed on the cutterblock. With a router table, we need to do what we did earlier when working freehand – that is, stick strips of iron-on melamine or veneer tape to the outfeed half of the fence. These match the depth (or width) of the cut – one to three pieces of tape may be needed. The cutter needs to project from the fence by this amount (see Fig 7.35). If an edge is bowed you should run the centre part over the cutter before planing the rest of it (see Fig 7.36). This should then true up the edge so that it is acceptably straight and square.

8

Making joints

JOINTING BASICS

FIRST AND FOREMOST, you must prepare the timber properly, because jointing doesn't work well with unsquare and unevenly sized parts. Remember that some matched cutter sets, such as the profile and scribe, require one half of the joint to be cut face down, while the other half is cut face up (see Fig 8.1). The thickness of the stock is critical: it must be the same throughout or the finished joints won't be flush (see Fig 8.2). A table saw and an electric planer table are the ideal way to prepare timber (see Fig 8.3), although prepared softwood from a timber merchant is pretty good if chosen carefully. Most measuring and checking can be done with an expanding steel rule, a 30cm (12in) steel rule and a medium-sized engineer's square – not a carpenter's square, because they aren't very accurate. Precise settings on the router table itself can be checked with vernier callipers. There are some cheap imports of this tool, and even plastic versions for those with small budgets (see Fig 8.4).

With all cabinetwork, let alone table operations, it is the norm to mark up all chosen faces with a face mark and an edge mark (see Fig 8.5). This means that you have taken the trouble to choose the best face and edge, and it ensures that any operation, such as moulding, is done on the right side, especially when you find that more than one operation is needed.

FIG 8.1 Profile and scribe parts in machining attitude to emphasize the face-up/face-down cutting procedure.

FIG 8.2 A joint face that is not level.

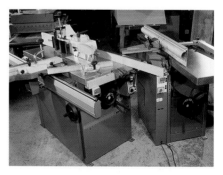

FIG 8.3 A French Kity sawtable and planer, of professional quality.

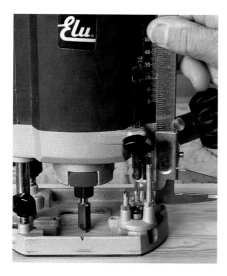

FIG 8.4 Checking cut depth with vernier callipers. They are also good for measuring the wood itself.

FIG 8.5 Making a face and edge mark.

Not surprisingly, some terrible mistakes can occur if this isn't done, so follow good workshop practice by marking up all your components before machining. Mark them with their function or size, too, so that you can sort them into piles for machining (see Fig 8.6) and re-sort them for assembly. Terms such as 'stile', 'rail' and 'muntin', denoting

FIG 8.6 The correctly stacked components.

respectively the vertical strips of a door or carcass frame, the top and bottom strips, and the vertical one that sits between the top and bottom rail when a door or panel split into two, (see Fig 8.7) are the usual ways of showing which piece is which. Abbreviations are handy. Use an H or HB pencil for writing on wood, because anything harder will permanently scar the work. Marking up joints accurately requires a hard pencil and a sharp one, or better still a small knife or cabinetmaker's awl, because these leave thin lines that are easy to work to (see Fig 8.8).

Where machined edges are fluffy, as with the 'fingers' made by a finger jointer or with decorative mouldings, these will all need

FIG 8.7 An assembled frame with a muntin.

FIG 8.8 Various tools for marking joints. From top to bottom: an engineer's square, an awl, a knife and a sharp, hard pencil.

FIG 8.9 Fine sanding mouldings by hand before assembly.

'carpenter's aliphatic resin' (see Fig 8.10), which is very good and has a 'high tack rate', which means that it starts to grip the wood quite quickly. Use proper cramping methods, such as sash cramps (see Fig 8.11), in order to close the joints, and check that the frames are square and that panels and so on are truly flat once the cramps are tightened.

When you have cramped everything, wipe off the glue with a damp cloth, or just let the glue go 'plasticky' and scrape it off with a second-best chisel – this avoids 'raising the grain' by getting the wood wet.

Once the glue has set overnight, you will need to level the front and back faces of the

FIG 8.10 Aliphatic resin, PVA glue and Cascamite powder.

FIG 8.11 Sash cramps in use. If the glue gets on to the cramps, it can pick up an iron stain which may be transmitted to the wood. The paper prevents this.

light sanding before assembly – sanded to a 'finish' in the latter case (see Fig 8.9), because it is almost impossible to do it after it is glued up.

Don't overdo the gluing, especially if there are loose components, such as the panel in a frame and panel door. PVA white glue is fine, as is Cascamite, especially for exterior work. There is also a light yellow glue known as

FIG 8.12 Belt sanding a frame. An orbital palm sander is standing by to finish off the job.

work, because it is often the case that joints are not as smooth as they should be. Some careful sanding, with a belt sander followed by an orbital sander, for instance, (see Fig 8.12) will tidy up the work and will give you a good finish.

Tongue and groove joint

The tongue and groove is a joint of long standing and has proved to be invaluable where large areas need to covered with panelling. It is formed of narrow unglued strips, each of which has a tongue on one edge and a matching groove on the other. It may also have bevelled front edges which form decorative V grooves when the joint is assembled – the whole joint being known as 'TGV' (see Fig 8.13). An alternative is the loose tongue, which is glued together to form a larger rigid panel.

This most basic of joints can be done with two different kinds of cutter. You use a normal straight cutter – a narrow one – to groove the stock as it passes through. It should be standing on edge against the fence (see Fig 8.14). Then you use a wider cutter, say 19mm or bigger, set well down in the table to cut the

FIG 8.13 A tongue and groove joint with bead and V groove added for interest.

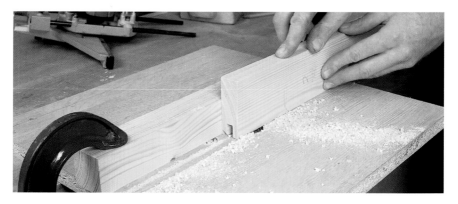

FIG 8.14 Cutting a groove with a straight cutter.

FIG 8.15 Machining the tongue on a small corner block.

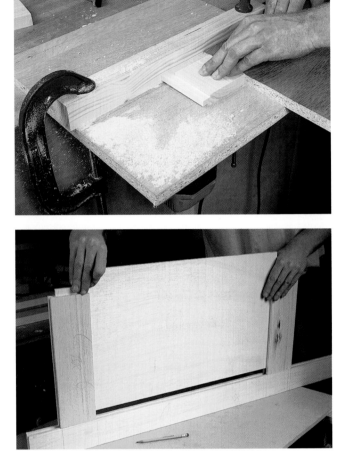

FIG 8.16 Assembling tongue and groove components. In this case, a panel is being added.

tongue. To do this, you need to lay the workpiece down and machine from each face in turn to leave a tongue (see Fig 8.15) that will fit the groove already cut (see Fig 8.16). The results can be a bit uneven, and the cutter that does the grooving can come under quite a bit of strain, especially when the groove becomes choked with chippings.

A better way to cut these joints is to buy a dedicated tongue and groove cutter set. This consists of two wide groovers to cut the tongue, mounted on an arbor with a bearing

to maintain correct depth, and a narrow groover for cutting the slot. Various companies, such as Trend and Wealden, make these sets (see Fig 8.17). Generally an 8mm, or $\frac{1}{2}$in, collet router is required to use them.

Make sure that you understand the order in which the components fit on to the arbor, and prepare to cut the groove first and the tongue second. A test cut is necessary and, certainly in the case of the Wealden set, the groove may need to be altered by using some 'shims' – very thin washers which are

FIG 8.17 Wealden's large tongue and groove cutter and shim set. The shims are for adjusting the fit.

FIG 8.18 Using a straightedge to check that the cutter bearing is flush with the fence.

supplied. Mark the shim or shims that give the best fit with a felt-tip pen so that you can get quickly set up next time. Once you have the machining set-up worked out, you can proceed with the actual work.

The fence position is also important, so check the instructions to see how deep the groove and how wide the tongue are supposed to be. Usually it will be obvious, because these sets usually have a large, mounted bearing and the diameter of this determines how deep the groovers cut as the work runs against the bearing. Shaped work can be done without a fence – using a 'lead-in point' instead – but normally you use the straight fence, set so that the bearing is flush with the front (see Fig 8.18). A straight through-fence facing helps when doing the scribing cuts, because it will allow the end being cut to run smoothly through the cutter without getting unintentionally pushed – which would cause uneven machining on the end (see Fig 8.19). In order to get the cutter to penetrate the fence you first need to cut a slot in the facing that will accommodate the arbor and the bearing (see Fig 8.20), but allow the two groovers to cut their way

FIG 8.19 A damaged scribe cut, caused when the workpiece was pushed into the opening in the fence.

FIG 8.20 A precut slot in the through fence for the tongue cutter.

FIG 8.21 Drawing the fence back on to the cutter so that the cutter breaks through the wood.

FIG 8.22 A corner lap joint, and an edge to edge lap joint (long grain).

through the fence as it is drawn back on to the running cutter (see Fig 8.21). Once at the correct position, lock the fence, switch off and check that all is well for a test run before machining.

Don't jiggle the fence around when pushing it back on to a running cutter – the cutter will catch the fence and kick it away. Make sure there is an off switch close by.

Rebate

In Chapter 7 we looked at the rebate simply as a rebate in its own right. Here we need to consider it as a joint where two rebates are fitted together as a lap joint (see Fig 8.22) or even as a corner joint. If the components are going to be rebated and joined along the 'long grain' edges, then only a fairly narrow rebate is required, because any kind of joint made with the grain is much stronger by far than any 'cross grain' join. This is because the fibres of each piece of wood lie quite sympathetically side by side, pretty much as they did when the timber was part of a living tree. The glue then completes the joint. Joining end or 'cross grain' together, or even to the long grain of another piece, isn't likely to succeed, because the pores or vessels have been severed (see Fig 8.23). It is about as effective as trying to rejoin two pieces of garden hose with glue! If we

wish to glue two pieces of wood end to end, we need to improve our chances by extending the long grain surfaces that meet. We call it the half lap joint.

Half lap joint

By lengthening the rebate (see Fig 8.24), the end grain surfaces become less important and the joint becomes stronger. However, this is not a suitable method for a joint that will be put under a lot of stress. As with

FIG 8.23 Severed end grain. Note the 'tail' on the trailing edge of the cut.

FIG 8.24 An end-to-end lap joint.

FIG 8.25 A badly 'stepped' joint.

other joints, it is important that your stock is the same thickness. You are machining only on the 'face side' of both parts and then turning one part over. If they aren't the same thickness you will get a stepped joint (see Fig 8.25). Alternatively, you can have one piece at 90°, as a flat corner joint for a frame. To machine the half lap joint, several passes over the cutter are needed to get the full width of cut. The best plan is to use the straight fence as a length stop for each component and use

the mitre fence, as with all scribing cuts, to feed the work over the cutter. Starting at the end, push the workpiece towards the fence by nearly the width of the cutter before each successive pass, until on the last pass it touches the fence and you have arrived at the full width of cut (see Fig 8.26). Make sure that you have a backing piece of wood screwed to the mitre fence so that it almost touches the fence. The work will then be properly supported to minimize 'breakout'.

FIG 8.26 Cutting a lap on the table – last pass.

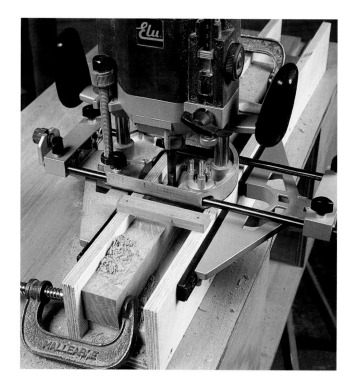

FIG 8.27 A mortise box. The workpiece is clamped at both ends, a stop limits the length of the socket.

Mortise and tenon joint

This, the basic frame joint of all time, transfers quite well from the mallet and chisel to the router. I covered it to some extent in Chapter 6 (Jigs and templates), but whereas the earlier mortises were for locks and hinges, here we look at a complete joint.

Always make the mortise first, because it is easier to make the tenon fit the hole rather than the other way round. This time we are going to make normal frame joints such as you would make for a chair or table underframe. A more appropriate means of controlling the mortising operation is needed, hence a wonderful item called a 'mortise box'. This is in fact a U-shaped trough, accurately made and designed to hold the workpiece in the box while the router slides along the top (see Fig 8.27).

Two slim cramps are needed to hold the workpiece against one side, and the router has to be kept 'on track' by fitting the fence with its rods on one side of the box and a second fence on the other side. Thus not only will the router run in a straight line, but by undoing its own lock knobs it can be slidden across to make passes at different widths to increase the overall width of the mortise. The last thing you do is to fit some movable stops at each end so that the mortise length can be altered. The depth is controlled by plunging as usual, although it is vital to put packers under the workpiece to maximize the depth of cut. It is possible that a router without long fence rods or an adjustable fence could be fitted with a thin MDF sub base instead, and this could have strips either side to slide along the sides of the box.

Unless you can buy a special jig for making routed tenons, the easiest way in the workshop is to use the router table and treat tenons as if they were lap joints, except that each tenon is normally 'shouldered' on all four sides instead of just one. This will require four separate operations. Each part will have both faces cut followed by both edges, making a sequence of two operations with different cutter settings for face and edge. Obviously, you need to work out the right proportions for your mortise and tenons. This will vary according to the size of wood you are using (see Fig 8.28). Routed mortises have rounded corners, so you have a choice of either squaring them out with a sharp chisel or rounding off the tenons. If you are not confident with the chisel, opt for the latter (see Fig 8.29).

The tenons should be a close fit for the hole, but they shouldn't need to be driven in with a mallet. A little experimentation may be needed to create joints that can be put together without damaging them: you may need to adjust the cutter height slightly. Another key point is to make the tenons slightly shorter than the hole. This allows room for the glue.

If the mortise box is deep enough, it will even allow awkward-shaped components to be mortised if the section to be mortised is perpendicular to the cutter (see Fig 8.30).

FIG 8.28 Checking the fit of a typical mortise and tenon joint.

FIG 8.29 Paring down the tenon edges.

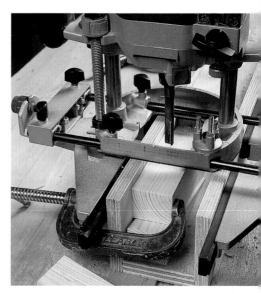

FIG 8.30 A close-up of the mortise box holding an angled workpiece. Wedges are being used to make it level.

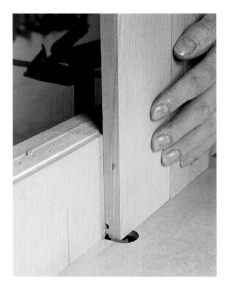

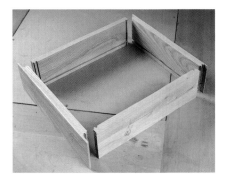

FIG 8.32 A drawer box taken apart to show the groove for the bottom panel. When installed, the front will oversail the sides to hide the drawer runners.

FIG 8.31 Cutting the vertical part of a drawer lock joint.

Lock mitre or drawer joint

Nothing to do with locks, of course. This rather large and impressive cutter has an interlocking joint shape on the edge, hence the name. It comes in two or three sizes and is largely intended for creating 'drawer boxes' – or drawers to you and me. The box is the basis for modern drawers. The front panel is usually added afterwards to finish it off, whereas on traditional drawers the front is integral to the drawer.

The lock mitre is used on all four vertical corners and needs sequenced machining. One half of each joint is cut with the component lying down on the table, while the other half is cut with it standing up against the fence. Note that a high fence facing has been fitted for precise, safe support (see Fig 8.31). Certain other operations, such as panel raising, also require a high fence, otherwise the cut can be uneven and the operation can be precarious, to say the least. Test cuts are vital to achieve good results, so

keep some spare pieces of wood handy for this purpose. In addition to the mitres, the drawer bottoms need to be fitted. These slots can be done with a straight cutter or a groover before you assemble the box (see Fig 8.32). Cramping is critical, because if the pressure is applied too far from the corners the mitres can 'yawn', or open up, and the drawer sides will be bowed (see Fig 8.33).

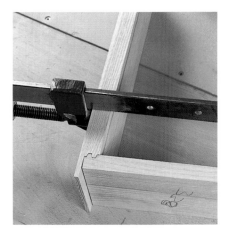

FIG 8.33 A drawer box that has been badly cramped, causing the joint to open.

Biscuit jointing

My favourite joint method by far is the biscuit plate or 'spline'. I use a jointing machine most days of the week (see Fig 8.34), but on the grounds of cost and for certain difficult jointing situations the router has the advantage. There are several cutter sets on the market, including Trend Cutters who produce an economy set and a professional set (see Fig 8.35). Each consists of a groover large enough to cut the slot needed, and three bearings so that slots for each of the three standard biscuit sizes can be made.

The economy set varies from the professional one in having a two-bladed cutter instead of a four-bladed one. For occasional use that's fine – the heavier-duty version is necessary only for regular and repeated use.

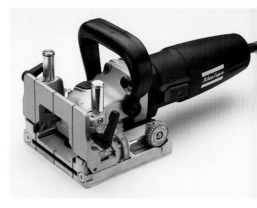

FIG 8.34 A typical professional biscuit jointer. Note the slot at the bottom for the blade.

USING A BISCUIT JOINTER

Each 4mm thick, elliptically shaped biscuit is cut from compressed beech with the grain running diagonally to prevent it breaking when the joint is together. There are three standard sizes: 0, 10 and 20. These cope with all the usual-sized joints. There are various specialized types as well, though these are really only of interest to professional users, especially as they are expensive.

FIG 8.35 The CMT three-wing and the Trend 'Craft Range' two-wing biscuit cutter sets, with the three standard biscuit sizes and the Lamello red-barbed assembly biscuit.

Method

1 Make a mark across both components at every point where a biscuit joint is required (see Fig 8.36).

2 Run a small amount of PVA glue into each slot and insert a biscuit.

3 Close the joint with cramps. After a while the biscuits, having been compressed in manufacture, begin to swell up and grip the sides of the slot. This is helped by a hatched grip pattern on each side (see Fig 8.37).

FIG 8.36 The joints marked up and the slots cut. Biscuits standing by.

FIG 8.37 The joint glued together. Note the two marks needed for each slot.

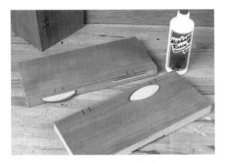

FIG 8.38 An elongated biscuit slot with marks.

FIG 8.39 Butt and corner joints. The T joint is only possible using a 4mm straight bit or a jointer machine.

Once the glue has dried, a neat, strong and invisible joint is formed. It is an ideal joint for carcass construction (see Project Chapters 23 and 24) and, because of the low cost and ease of use, many biscuits can go into a piece of furniture, often substituting for more conventional methods.

It is difficult to describe on paper just how fast and easy the technique really is, but I have no hesitation in recommending it to anyone – even a relative beginner.

BISCUIT JOINTING WITH A ROUTER

The router method is slightly different, however. The first thing is that the machine needs to be plunged so that the cutter is approximately in the middle of the board to be slotted. Once plunged, it must stay like this until the machine has been moved away from the workpiece. Unplunging while in the wood will cause the slot to be widened, making it useless. The other thing is that biscuits are meant for use with a jointer machine which has a blade 100mm ($3^{15}/_{16}$in) diameter, while a groover is much smaller. Because the slot is therefore shorter, it is necessary to make a second mark each time and slide the router up to it to elongate the slot (see Fig 8.38). The radius at each end of the slot doesn't conform to the biscuit shape, but it still works reasonably well. One last point is that the router can only cut butt joints, edge-to-edge joints, corner joints or T joints with a narrow crosspiece (see Fig 8.39). This covers most things, but the jointing machine can work T joints well away from any edge.

I have already shown you the basic working method, but here are one or two tips that will help. Apart from normal carcass material, such as chipboard, ply and MDF, the biscuit can be used on solid wood. Large sections can be effectively joined using two rows of biscuits for

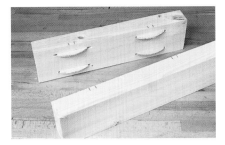

FIG 8.40 A double row of biscuits in large section timber.

extra strength (see Fig 8.40), although the machining should be done from one face only, so avoiding any misalignment between the rows of slots which would prevent the resultant joint from closing.

Biscuits are a perfect locational aid and can be used to ensure that corners of carcasses really do come together square even if some screws are used as well to tighten the whole thing up. Kitchen cupboards and wardrobes are good examples of this 'locate and fix' method (see Fig 8.41). It also works when gluing and cramping large surfaces together. Boards can slip out of alignment when being cramped, because glue tends to be 'slippy'. A few biscuits will ensure that this doesn't happen.

A pencil can damage a surface finish such as veneer or lacquer, so run masking tape along both sides of the joint and mark this instead. The router can sit on the tape while it slots, and the tape can be peeled away later.

Place the biscuits 152–254mm (6–10in) apart for adequate strength. There are exceptions to this: narrow components can take biscuits very close together if necessary, becoming in effect a semi-continuous tongue and groove (see Fig 8.42).

Always use the biggest biscuit practicable. I use size 20 most of the time. You can buy boxes of 1000 biscuits with a mixture of all three sizes, which saves you

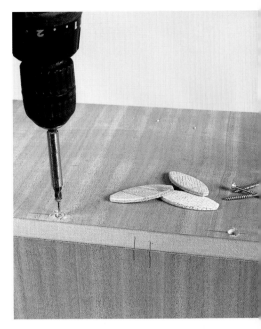

FIG 8.41 The biscuits help to 'locate' each part of the carcass while the screws fix them together.

FIG 8.42 Biscuits used to make a tongue.

from buying too many of one size. Keep your biscuits in polythene bags or boxes to prevent them from getting damp, because this will make them swell up.

9

Dovetailing

DOVETAIL JOINTING is synonymous with cabinetmaking, just as the mortise and tenon is with joinery. Years ago, proper hand-made dovetailed drawers were very much the order of the day. Times have changed, however, and although some skilled craftsmen still cut dovetails by hand, machine-based methods have largely taken over these days.

The dovetail combines skill, visual appeal and incredible strength, because the shape of the very aptly named 'tails' interlocks with the opposing 'pins' (see Fig 9.1). It comes in a variety of types, some purely functional, others much more decorative.

For years now, there have been fairly simple jigs available for routing dovetails. These have been joined more recently by a

handful of much more sophisticated jigs, designed not only to copy some of the finer examples of hand dovetailing, but also to push back the technical boundaries and thus produce new varieties of this joint never possible before (see Figs 9.2).

I have cut dovetails by hand in the past, but I would describe my ability as average. I have tried out simple dovetail jigs, such as the Dewalt/Festo and Bosch types, to see if they deserved a place in my workshop but, to be honest, the resulting joints looked rather 'machine made'. However, there is some merit in using them, because they add strength to any construction. The more sophisticated jigs are not only very expensive but also very good, because they can create such precise and exotic jointwork. Really I

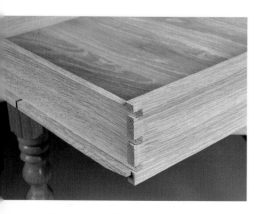

FIG 9.1 A typical dovetail joint, largely unseen when used on drawers.

FIG 9.2 Finished joints which have been produced on the Leigh jig.

think you need to weigh up your level of skill both with the router and with woodworking generally, and decide whether you really need to use one of these jigs when there are plenty of alternative jointing methods available.

USING A JIG

Here, briefly, is a description of how to use the DeWalt/Festo/Bosch-type jig.

These jigs are formed of pressed steel and can be cramped or screwed to a workbench. There are two clamping bars, one on top and one on the front. These hold the two components which form the two halves of the joint. On the top, there is also a piece of alloy with U-shaped cutouts on which the router sits. To use the jig, the correct dovetail cutter must be fitted. All dovetail jigs require a specific cutter, or cutters, and a guide bush for correct use, and most manufacturers' cutter ranges have these cutters noted in the specification, so it is quite easy to both identify and buy them from different sources.

The cutter is set at a specific depth using a little setting-up device. In addition, fitting a fine-depth adjuster to the router helps you to achieve precise depth setting and prevents the router from suddenly 'unplunging' and damaging the jig or cutter. Once you have preset the depth of cut, you have to clamp the boards to the jig. The vertical position cuts the 'tails' which are all separated from each other, while the horizontal clamping position holds the piece that will have the 'sockets' machined into it: these are joined continuously. The router runs along on top of the shaped steel template, going in and out of each U shape, thus creating each joint shape. It is, of course, necessary to do some test pieces in order to get the correct fit before cutting into vital components. Typical uses for these 'common dovetails', as they are known on account of their even spacing, would be for small carcasses with exposed

jointwork or for drawer boxes. These jigs can also be converted for making square finger joints which I happen to feel are rather better looking, if not so rigid and self locking as the dovetail. The versatile Bosch can also be used to make dowelled joints.

CLEVER JIGS

'Clever' jigs like the Leigh, Incra and Woodrat are simple in theory but rather more complicated in practice, partly because of the profusion of scales and adjustments. They are made to very fine engineering tolerances and need to be looked after properly. That said, they are ideal for anyone who likes a challenge and who aspires to greater degrees of excellence.

FIG 9.3 The Incra Ultra Jig – more scales than a fish!

The Incra Ultra jig

An all-American device, this has come some way from the original simpler model and is now an impressive affair with precision-milled knobs and various add-on scales. What the Incra jig allows you to do is make cuts in absolutely precise and repetitious positions so that you can accurately produce dovetails and finger joints of all types and sizes. It isn't intended for heavy grade work

but for fine cabinet joints and boxes. One of these is the double-double box joint, which is an all-new Incra-created 'joint within a joint'. There are plenty of other possibilities.

The original jig had a 'saw tooth' racking system for moving the fence across to repeatable positions. This newer model has a 'clamp and lock' system based on new tooth racks backed up by a variety of add-on scales. It looks confusing and, indeed, it is - requiring a methodical mind to get the right result from it (see Fig 9.3). The jig is fixed to a piece of board which is itself clamped to the router table. Once correctly aligned to the cutter in use, the jig gives precise data from which each cut can then be accurately set up. The fence part has a sliding end stop for doing 'stopped' work, and there is a pushblock also made from extrusions. It is possible to use this jig as a super-accurate sawtable fence, although this would depend upon the quality of the table and blade, and the Incra jig would be vulnerable to damage by the blade.

There is a 'Master Reference Guide and Template Library' available, which is a large book showing life-size joints and matching scales that are needed for making them. This is a very 'focused' fine-jointing system for the

FIG 9.5 The adjustable jig bars are set for a 'common' dovetail.

FIG 9.6 Machining the sockets or pins ready to accept the 'tails'.

dedicated dovetail enthusiast, but possibly not the right gadget for the rest of us. See the video first!

The Leigh dovetail jig

To look at, the Leigh jig is not dissimilar to the Dewalt/Festo jig, but in fact it is much more versatile and very precise indeed (see Fig 9.4). The components are clamped both on top and in front, while an alloy bar over the top carries a series of shaped alloy 'fingers'. These slide along and can be locked wherever they are needed, a sliding scale allowing front to back adjustment. The router sits on the fingers and is moved in and out between the fingers in order to form the two halves of the joint (see Figs 9.5 and 9.6).

FIG 9.4 The legendary Leigh jig in its basic form, capable of endless joint variations.

What makes the Leigh special is the 'build quality' and its adjustability, coupled with its own range of TCT cutters and, most importantly, a complete range of guide bushes and mounting plates for all known routers. These guide bushes are vital for the Leigh jig to operate properly. There is also an adjustable mortise and tenon jig, and a precision-machined finger-joint jig with a variety of joint sizes available. With its very comprehensive user guide, and its ability to do shelf stud holes and dovetail housings, it is a very versatile and efficient system for any really keen woodworker.

The Woodrat

This ingenious British-made router jig is very well thought out and versatile. The Woodrat can cope with a range of components, from the very small to quite large joinery items. It has the advantage of working best in wall-mounted mode which, if you have a spare piece of workshop wall, makes for a very compact means of working. The jig consists of a strong, precision-made piece of aluminium box extrusion. There is a plate on top to which the router is attached and there are two clamping positions on the front for the workpiece. The router is wound by a handle from side to side, allowing it to be moved carefully to each machining position. It is then pulled forward to make each cut of the joint (see Fig 9.7). The router can be swung from side to side within preset limits, so that dovetail pins can be cut as well as the tails, the two operations needing different cutters. Woodrat's own HSS cutters work much better on natural timbers than do tungsten carbide cutters, provided they are kept razorsharp with frequent honing. One clamping position is used to hold the component which has the tails marked on it, while the other position holds the one which is being cut, using the first set of markings as a guide. They are then swapped over to complete the joint.

This device can also cut lap, tongue, finger, mortise and tenon joints, housings and even profile joints, making it far more than just a plain dovetail jig. There is an inspiring video available which shows the real potential of this versatile jig.

This chapter can only really scratch the surface of what these jigs are capable of. If you progress far enough with routing, it is worth taking a good look at them to see how they could further your interest in joint-making.

FIG 9.7 The Woodrat.

FIG 9.8 Dovetail housing.

FIG 9.9 A T-square for cutting housings with a guide bush.

DOVETAIL HOUSINGS

Unlike the dovetail joint, the dovetail housing does not require one of the jigs described above. The difference is that the housing is one long sliding dovetail on the end of a board which then fits into a matching slot on a carcass. It's a neat, strong, invisible joint and it can be made with a home-made jig. The dovetail also resists movement across the width of the board – the board cannot bow or warp out of shape, because it is 'locked' in place (see Fig 9.8). As

it isn't glued, both boards are free to shrink or expand across the grain without splitting.

The housings can be run over a dovetail cutter in the router table. Use a protractor fence to push them and have a stop board clamped across the table to limit the cut if this is required (i.e. a 'stopped housing'). You will need a jig for larger pieces so that the router can sit on the work to rout the slots. This can take the form of a T square jig (see Fig 9.9), which has a slot down the middle to take a guide bush. Across the end there is a bar to locate it against the edge of the component. Fix it in position with a couple of cramps. If the slot is long, you can put scale marks along the side so that you can machine housings of different lengths.

The other part of the joint, the tail, is done vertically on the table, with the cutter just protruding far enough out of the fence. It is important to have nice flat components and to press them firmly against an extended fence for good support (see Fig 9.10). Efficient sideways hold-downs will help, too. All this is necessary, because it's easy to create a poor joint. Various test cuts are required as well, in order to get the fit as snug as possible. It should be possible to tap the joint together with a mallet and block, but without using excessive force. Long boards can be cut freehand overhead, using an L jig (see Fig 9.11)

FIG 9.10 Cutting a dovetail for a housing – on a router table.

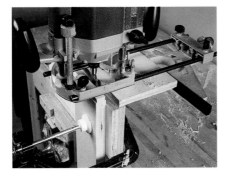

FIG 9.11 Cutting a dovetail on a long board end (freehand), using an L jig.

FIG 9.12 Cutting the end of a dovetail to fit a stopped housing. Note the high facing fitted to the mitre fence.

With stopped joints, the tails need to be cut at one end. This can be done after you have cut the sides of the joint – you'll need a protractor fence with a high facing (see Fig 9.12). Breakout around the end of the joint can occur, although it will almost certainly be hidden once the joint is closed. Also the end of a 'stopped tail' has to be rounded in order to fit the slot. A little judicious chisel work is called for and will remove any torn corners. With this joint it is possible to assemble a whole carcass, such as a bookcase or shelf, quite successfully, and it will be a very rigid structure even without a back panel.

FIG 9.13 Using a £10 note to make the last pass no more than a whisker.

WORKING TIP

By moving the router table fence, do several deepening passes to get a good dovetail fitting, but stop short of a final pass as it will almost certainly take off too much. Instead try another pass at the same fence setting: you may be surprised how loose it is! Keep a £10 note handy; it is thin enough to pack or 'shim' between the workpiece and the fence on that second pass and thus reduce the amount taken off to a whisker (see Fig 9.13). This may be all you need for a good fit.

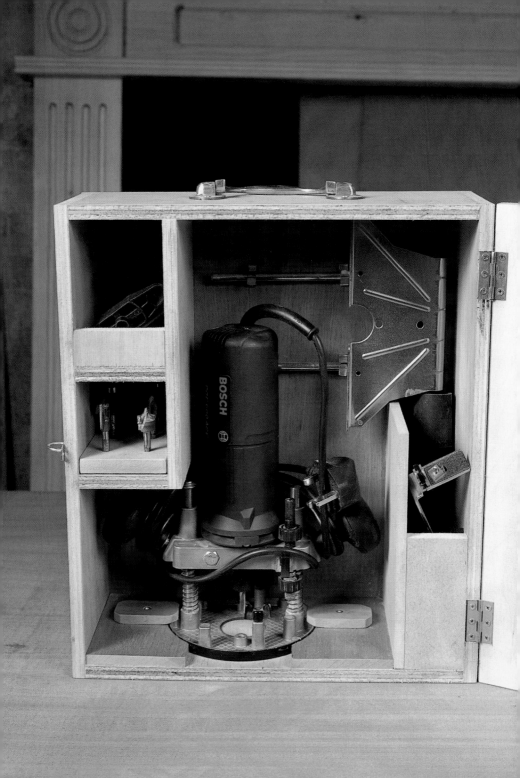

WORKSHOP PROJECTS

In this part of the book we can put into practice some of the operations discussed earlier, this time not in isolation but as part of a whole series of work processes that lead to a natural conclusion. A key part of this is performing the operations in the correct order (although this order may be variable). As I go through each project in turn there will be various tips and safety hints which may have been mentioned previously, while others are touched on for the first time. It is important to read Chapters 1–9 first and only then to start attempting projects and incorporating the 'working tips' that accompany them. Routing is a big subject: refer to earlier chapters when necessary, and don't expect everything to go perfectly first time. Observe for yourself how the router, cutters and wood behave in practice, and try to devise your own solutions to any problems not covered here. Above all, enjoy what you're doing – that's the most important advice of all.

10

Cutter selection boards

Storing cutters safely is important, and so is being able to choose them at a glance. One good way of storing them is to slot them into a board which is kept dust free in a cupboard or fixed to the wall and fitted with some sort of cover.

A cutter selection board is most likely to be rectangular or square, but you may wish to make a circular carousel instead (see Fig 10.1). This allows you to store a large collection of cutters, which might include several of the same pattern in different sizes, hence the need to rotate the board for selection.

Square or rectangular pieces of board can be cut out with a saw or router. The circular board is a slightly different matter. It needs to be cut with a router trammel – a sort of overblown drawing compass - but with a cutter instead of a pencil. You can cut repeatedly at progressively lower plunge depths until you have machined right through.

WORKING TIP

Don't cut out your boards on the router table. It requires the 'drop on' method which means working blind, because you can't see where the cutter is moving underneath. The cutter will not only come right through on the last pass and pose a risk to your fingers, but the centre piece will finally come free and catch on the cutter. This will probably just mark your work, but the clatter it makes is disconcerting. Instead, work 'overhand' with the router on top of the wood, fitted with a top-mounted bearing-guided cutter (see Fig 10.2). The router base will tend to hold the loose piece in place. In addition, a strip of double-sided sticky tape between the workpiece and the surface beneath is a good idea. Don't cut into your workbench – always use a spare piece of board for through-cutting work.

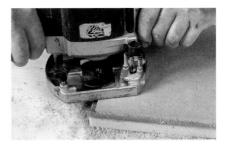

Fig 10.1 Two different kinds of cutter board. Note the finger slot under the ends of the rectangular cutter board.

Fig 10.2 Using the router 'overhand' to cut out the cutter board, with the template for guidance.

MATERIALS AND TOOLS

Materials

All components can be in ply or MDF, except where shown.

Rectangular cutter board	360 x 240 x 18mm	(14³/₁₆ x 9⁷/₁₆ x ¹/₁₆in)
Carousel board	350 dia. x 18mm	(13¾ dia. x ¹/₁₆in)
Carousel base	150 x 150 x 18mm	(5⁷/₈ x 5⁷/₈ x ¹¹/₁₆in)
Strip jig for drilling the rectangular base	280 x 100 x 6–9mm MDF 150 x 32 x 19mm softwood (planed or round)	(11 x 3¹⁵/₁₆ x ¼–³/₈in) (5⁷/₈ x 1¼ x ¾in)
Ballbearing race	Size not critical, although the centre hole needs to match the bolt that you use	
Bolt	8–10mm dia. (can be cut to the required length)	(⁵/₁₆ x ³/₈in)
Epoxy resin		
Thin plastic glazing sheet (from any DIY store)		
Clear plastic weatherproof tape (from DIY store)		

TOOLS

Guide bush

¼in and ½in (poss. 8mm diameter as well) straight cutters for shank holes

A flatbit and mains or cordless drill to make template holes (flatbit dia. to suit guide bush size, or you can obtain a router bit that exactly matches the size of the guide bush)

A Stanley knife to score and break the plastic sheet or a saw table with a fine blade (eye protection vital)

A hacksaw, file and a simple metalworking vice with protected jaws (sheet zinc or copper is suitable)

Method

1 For a square board, decide roughly how many cutters you may end up with, what shank sizes they will have and roughly what diameters they could be. Let's assume they run from tiny to quite large. They don't need to be laid out in crisscross lines, but can be offset so that there are more small cutters in a row than there are large ones. Mark out where you want the holes for the cutter shanks.

2 Assess whether the cutters are in repetitious rows. If so, that would warrant making a drilling jig. A strip jig would be best, because this can be reused for making other cutter boards (see Fig 10.3). The spacing takes into account the cutter sizes, while the shank hole sizes are determined simply by swapping the cutters used with the jig. If the jig holes are large, this is best done with a suitable flatbit and drill (see Fig 10.4), because these are cheaper than the equivalent router cutters and quite good enough for the purpose. If there is an insufficient number of holes to make this jig worthwhile, just use the router as a freehand drill using the clear plastic crosshair base as described on page 90 and practise your marksmanship! A clear plastic dustcover can be made from pieces of plastic glazing sheet joined together with heavy-duty clear tape (see Fig 10.5).

3 The carousel board needs to rotate. On mine I used an old bearing out of my bits box, fitted a shaft (an old bolt) and then fixed the bearing into a routed recess under the carousel with epoxy resin. I fitted the bottom end of the bolt into a square wooden base and the carousel turns with only a touch of a finger (see Fig 10.6).

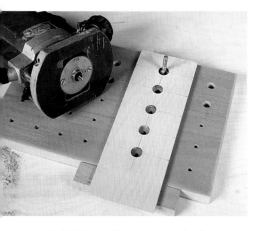

Fig 10.3 A strip jig for making the shank holes. The same jig works with both 1/4in and 1/2in shanked cutters.

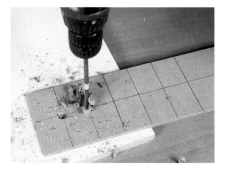

Fig 10.4 Cutting the jig holes with a flatbit and drill.

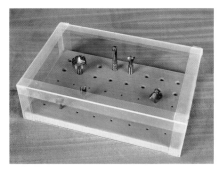

Fig 10.5 The cutter board with a clear plastic cover. The cover is stuck together with 'all-weather' tape.

Fig 10.6 The carousel mechanism consists of a sawn-off bolt and a ball-bearing race which have been stuck into the circular board and a square base with epoxy resin.

4 Whichever version you make, it's a good idea to bevel or roundover the edge. Fit a suitable cutter and do a test cut first to check the profile. This operation can be done on the table or freehand, though you will need to clamp it in the vice or down on to the bench so that it can't move around.

5 Once your board is complete, give it a good sanding to clean it up. For a neat job, ensure all setting out lines are erased when sanding. An orbital sander is handy for all flat surfaces, and sheet abrasive for hand-sanding the edges – and there you are, instant cutter reference.

WORKING TIP

It is difficult to set the roundover at an exact depth so that the shape flows smoothly on to the flat top face. Set it so that it is just a fraction high, thus not quite producing a smooth curve, rather than too low down, because this will score the top surface and will be difficult to sand out. Next, plunge again and recut at the same depth; you may find that the cutter takes out a fraction more on the second pass, especially with a little downward pressure.

11

Portable router storage case

Most professional routers come with a steel site case, but for some it may only be available as an extra. Small DIY routers don't have cases, though you might find a plastic case of some sort at a DIY warehouse. Steel or plastic, they are rather unlovely things, simply being functional and not always that. For more attractive storage, a properly fitted box or case is better (see Fig 11.1). I have designed this case to suit a ¼in collet small router, but the design can be altered for a larger machine.

FIG 11.1 The completed case with the router and its accessories.

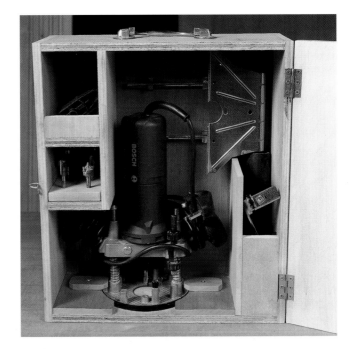

MATERIALS AND TOOLS

Materials

All components made of ply, except where shown.

Case sides (2)	410 x 140 x 12mm	(16⅛ x 5½ x ⁷⁄₁₆in)
Top and bottom (2)	360 (inc. 12mm for 2 x 6mm tongues) x 140 x 12mm (14³⁄₁₆ (inc. ⁷⁄₁₆ for 2 x 1/4 tongues) x 5½ x ⁷⁄₁₆in)	
Left-hand vertical divider	232 (inc. 6mm for single tongue) x 140 x 12mm (9⅛ (inc. ¼in for single tongue) x 5½ x ⁷⁄₁₆in)	
Base and shelf piece for above item (2)	140 x 90 (inc. 12mm for 2 x 6mm tongues) x 12mm (5½ x 3⁹⁄₁₆ (inc. ⁷⁄₁₆ for 2 x ¼ tongues) x ⁷⁄₁₆in)	
Slide out cutter board	139 x 89 x 12mm	(5⁷⁄₁₆ x 3½ x ⁷⁄₁₆in)
Right-hand vertical divider	210 (inc. 6mm for single tongue) x 140 x 12mm (8¼ (inc. ¼in for single tongue) x 5½ x ⁷⁄₁₆in)	
Front piece for above item	120 x 50 x 12mm	(4¾ x 1¹⁵⁄₁₆ x ⁷⁄₁₆in)
Shaped pieces to hold router base (2)	140 x 110 x 12mm	(5½ x 4�516 x ⁷⁄₁₆in)
Case door	410 x 360 x 9mm	(16⅛ x 14³⁄₁₆ x ⅜in)
Back panel	410 x 360 x 6mm (ply or MDF)	(16⅛ x 14³⁄₁₆ x ¼in)
Short strips of prepared wood to make the turnbuttons (2)	60 x 30 x 10mm	(2⅜ x 1³⁄₁₆ x ⅜in)

16mm (⅝in) hardboard pins or panel pins for fixing the backpanel

38mm (1½in) panel pins for fixing divisions (if omitting tongues)

PVA glue

Four small Terry clips

Some long pop rivets

A few short screws

A small hasp and staple and a suitcase padlock

A flip down brass handle or a luggage handle (from a good DIY shop or ironmongers)

A small piece of Formica or other sheet to glue under slide out cutter board

Contact adhesive for the above item

PVA glue

Two small brass hinges

Tools

A pop rivet gun

6.4mm (⅛in) straight cutter for freehand drilling of cutter board

19mm (¾in) or similar dia. straight cutter for trimming all components to size

A bearing-guided trimmer for trimming the back panel and door in situ

Home-made router T-square

FIG 11.2 Casework tongue and groove.

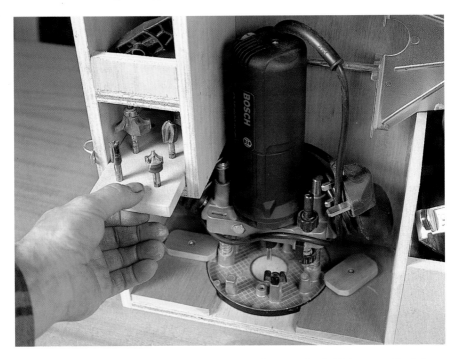

FIG 11.3 The cutter board slides out easily and the turnbutton strips hold the router firmly in place.

FIG 11.4 The completed case with a flip-down handle, and a hasp and staple with a padlock.

Note the use of tongue and groove for the casework (see Fig 11.2). This is easy to do, and gives positive location and – once the front and back are on – strength, too. There are some internal fittings which are cut to fit the individual machine and 'turnbutton strips' to hold the router in place (see Fig 11.3). There are also Terry clips for the fence and a compartment for all the little odds and ends. I have included a space for keeping half a dozen cutters, on the basis that if you take the router anywhere other than the workshop you should always have something to cut with, even if you forget the cutter box. A large case handle is needed (they are available from good hardware stockists), and the hinges need to be recessed in (see Fig 11.4).

FIG 11.5 The back of the case showing the pop rivets which have been used to fix the Terry clips inside.

12

Small router table

This small table is for a 1/4in collet router. It has the smallest area it is possible to have while still being safe and efficient.

FIG 12.2 The trammel base, showing the cutter, which has been plunged through it, and the bolt. The distance between the two represents the radius of the intended cutout.

Method

1 Ply or MDF are suitable. Start with two pieces of 9mm (³⁄₈in) MDF for the top. One of these needs a hole large enough to accommodate the router base, which will be either round or rounded at the ends with flat sides. Fit a piece of 6mm (¼in) MDF or ply to your router base, using machine screws – although double-sided tape may work if the base is free of dust.

2 Use a 6.4mm cutter to drill through this, and measure away from the cutter to a position that will give you the radius of the desired hole. This may be under the baseplate rather than off to the side.

3 Find a piece of small studding (threaded rod) or a bolt. Cut this to a length of 12mm (½in). Use the drill to drill a hole at the radius mark that is the same as the 'core' diameter of the studding. Wind the studding in with pliers so it sticks out 6 or 7mm (¼in) (see Fig 12.2).

4 Drill a hole in the centre of the intended circle cutout in the 9mm (³⁄₈in) MDF.

FIG 12.1 The complete table.

MATERIALS AND TOOLS

Materials

All components are MDF or ply, except for the fence (DIY superstores sell ready cut part-boards of MDF and ply).

Top	380 x 220 x 9mm	(14¹⁵⁄₁₆ x 8¹⁄₁₆ x ⅜in)
Underneath top panel	300 x 220 x 9mm	(11¹³⁄₁₆ x 8¹⁄₁₆ x ⅜in)
Back	300 x 300 x 9mm	(11¹³⁄₁₆ x 11¹³⁄₁₆ x⅜in)
Bracket ends (2)	300 x 208 x 9mm	(11¹³⁄₁₆ x 8³⁄₁₆ x ⅜)
Fence	380 x 45 x 34mm – finished size in softwood (PAR)	(14¹⁵⁄₁₆ x 1¾ x ¹⁵⁄₁₆in)
PVA glue		
Bolt or studding	5mm dia	(³⁄₁₆in) dia

Tools

A hacksaw and file

Drill and 4.5mm (3/16in) bit for drilling stud hole

16 or 19mm (5/8 or 3/4in) straight cutter for trammel cutting work and trimming components

Four cramps or a woodworking vice when gluing both top pieces together

This hole should be the same diameter as the studding or bolt.

5 Insert the bolt into the hole in the intended cutout. Then plunge the cutter and proceed to make a trammel cut by rotating the router about the studding (see Fig 12.3).

6 Put an even zigzag pattern of glue on one board and cramp the two together neatly. This will form the table top, though one edge will need to be trimmed flush first.

7 Cut out the back plate. This will be fixed in a vice when you are routing.

8 Lastly, cut two angled bracket pieces to fit on to the back plate (see Fig 12.5). Use glue and screws to assemble all of the

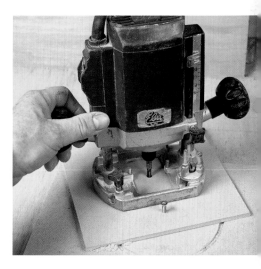

FIG 12.3 The router, with trammel fitted, being used to cut a circle.

FIG 12.5 Two matching bracket shapes attached to the back plate.

components and find a nice straight square piece of wood for a fence. This is merely held on with two G-cramps.

9 To fit the router, drill holes in the table top to match those in the router baseplate. If there aren't any holes, four wooden strips with screws will hold the router in place. Then put the table in your vice and away you go. Router tables don't come much simpler than this.

The reason for the highish vertical piece is to bring the table top within easy reach when working (see Fig 12.6). The only drawback with any inverted router is the lack of fine up and down adjustment. Fine adjusters are sometimes available as extras, otherwise it's a case of switching off and unplugging, leaning over the table to unlock the plunge lever, pulling the router up and relocking – not sophisticated or clever. Use the depth rod and turret as usual, so that you can at least bring the router up to a preset stop position each time you make an adjustment.

FIG 12.4 The flex hitched up while the circle is cut.

SAFETY TIP

After each pass, unplunge and swing back to your starting point. Don't keep going round and round, because the flex will get wound up. Also, find a hanging point above you and tie the flex out of the way (see Fig 12.4).

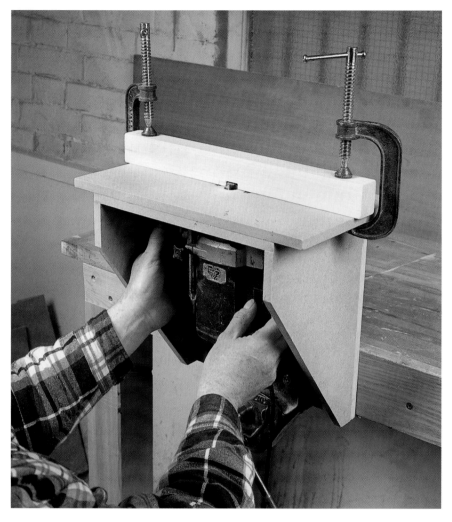

FIG 12.6 Using the table at a convenient height. A simple softwood fence has been cramped on.

13

Large router table

This project assumes that you have a large router and the room to store and use a large table. Unlike most manufactured tables, this has quite a large surface area – similar to a spindle moulder, in fact (see Fig 13.1). This is because the spindle needs a large table for safe operations and, although the router can make do with less, the same rule should also apply where larger pieces of work or large cutters are being used. Extraction and hold-downs must also be considered. This table isn't designed to stand on the floor, but you have the option to make it do so if you wish.

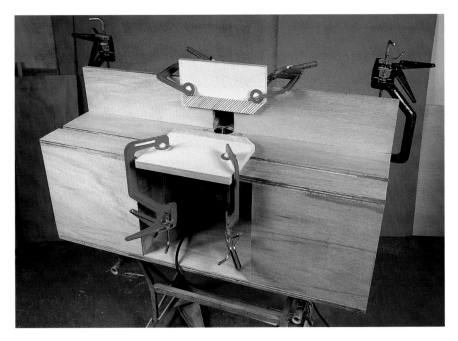

FIG 13.1 The large router table, complete with MDF spring fingers held in place with clamps.

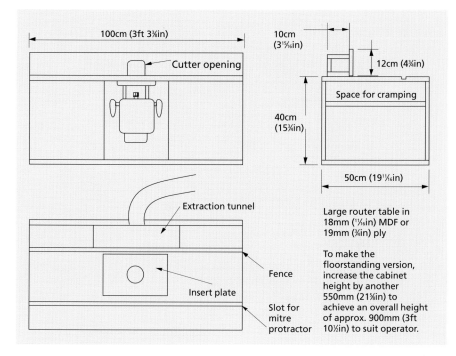

FIG 13.1 Plans for the large router table.

FIG 13.3 Machining freehand the centre recess for the router base. An inboard trammel has been used to obtain the outline shape, as shown in Chapter 12.

FIG 13.4 A ready-made insert plate, made of tough plastic.

Method

1. Start with a board of 18mm (¾in) thick ply. You can use other materials, but this is reliable. Cut all the major parts.

MATERIALS AND TOOLS

Materials

All components are ply except where shown (birch is best for long lasting quality, but more expensive).

Top and bottom (2)	1000 x 500 x 18mm ply	(3ft 3⅜ in x 19¹¹⁄₁₆ x 1¹⁄₁₆in)
Ends (2)	464 x 266 x 18mm	(18¼ x 10⁷⁄₁₆ x 1¹⁄₁₆)
Cramping recess vertical pieces (2)	464 x 80 x 18mm	(18¼ x 3⅛ x ⁷⁄₁₆in)
Cramping recess horizontal pieces (2)	464 x 90 18mm	(18¼ x 39/16 x 1¹⁄₁₆in)
Vertical divisions (2)	464 x 364 x 18mm	(18¼ x 14⅜₁₆ x 1¹⁄₁₆in)
Front panels (2)	364 x 325 x 18mm	(18¼ x 12¹³⁄₁₆ x ¹¹⁄₁₆in)
Back panel	1000 x 364 x 18mm	(3ft 3⅜in x 18¼ x ¹¹⁄₁₆in)
Fence		
Front face	1000 x 150 x 18mm	(3ft 3⅜in x 5⅞ x ¹¹⁄₁₆in)
Bottom piece	1000 x 100 x 18mm	(3ft 3⅜in x 3¹⁵⁄₁₆ x ¹¹⁄₁₆in)
Tunnel top	400 x 100 x 18mm	(15¾ x 3¹⁵⁄₁₆ x ¹¹⁄₁₆in)
Tunnel back	400 x 65 x 18mm	(15¾ x 2⁹⁄₁₆ x ¹¹⁄₁₆in)
Internal divisions and ends (4)	82 x 65 x 18mm	(3¼ x 2⁹⁄₁₆ x ¹¹⁄₁₆in)
Spring fingers	270 x 240 x 18mm MDF	(10⅝ x 9⁷⁄₁₆ x ¹¹⁄₁₆in)
Spring fingers	270 x 140 x 18mm MDF	(10⅝ x 5½ x ¹¹⁄₁₆in)
Protractor		
Baseplate	195 x 110 x 12mm	(7¹¹⁄₁₆ x 4⁵⁄₁₆ x ⁷⁄₁₆in)
Front face	240 x 45 x 18mm	(9⁷⁄₁₆ x 1¾ x ¹¹⁄₁₆in)
Bar to fit in table groove	330 x 19 (adjust for a good sliding fit in groove) x 10mm Hardwood PAR	(13 x ¾ x ⅜in)
Plenty of No. 20 beech biscuits		
PVA glue		
Plastic or metal insert plate (optional)		
Several round-headed bolts (to fit holes on your router base, diameter varies according to make)		
A NVR release switch		
A fine depth adjuster (or materials to make your own - see this chapter)		
Four clamps for holding the fence and spring fingers when table is in use		
Varnish and wax to give top some 'slip'		

Tools

Biscuit cutter set
4mm straight cutter for mid-panel biscuit slots
Jigsaw or bandsaw for cutting spring fingers
Hacksaw and file for cutting router fixing bolts

FIG 13.5 The internal divisions give the table its strength.

Make a recess for the router base in the top piece using the trammel method as shown in the previous project chapter. If the router has a flat base side or sides, use a fence first to cut that part of the recess, then do a 'stopped' trammel cut up to it. This time, however, cut just half way through and then use the router freehand with a larger straight cutter to clean out the centre (see Fig 13.3). Start in the middle and work towards the outside so that the router has adequate support underneath. Alternatively, you can machine out a circle or square shape on top ready to fit a ready-made insert plate. This has the advantage of being strong, and the machine screws which will hold the router cannot pull through as they eventually will with a plywood top. Trend and other suppliers make proper centre plates with inserts (see Fig 13.4) for home-made tables.

Note that there are internal panels either side of the router to hold the top level,

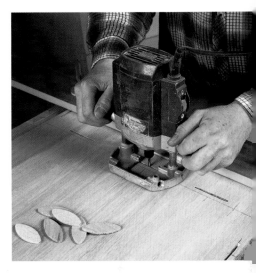

FIG 13.6 Cutting mid panel biscuit joints with a 4mm straight cutter.

because a large area of board would sag with age (see Fig 13.5). These also prevent the inside of the table getting choked with dust. The front panel is split into two, so there is clear access to the router for adjustments and cutter changing.

Use biscuit joints, because they are a very quick and accurate way to get a result. Put strike marks at regular intervals along all edges and where internal panels are to be fitted. Choose No. 20 biscuits (normally the largest available size) and using a Trend or similar jointing set with the correct bearing fitted, cut all the joints (see Fig 13.6). Those joints that are away from carcass edges, beyond the reach of the cutter, need to be cut using a 4mm straight cutter and a straightedge for guidance.

Glue and assemble the end pieces first and set them aside to dry, then lay the top face down and start fitting all the parts in their correct positions.

WORKING TIP

Keep your biscuits in a polythene ice cream container or plastic bag, to seal out moisture that could make the biscuits expand and render them useless.

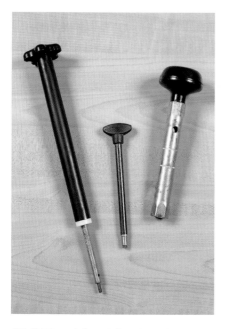

FIG 13.7 From left to right: a large fine adjuster, a small fine adjuster and a home-made version.

WORKING TIP

Many routers have a threaded rod at the back. This has a captive nut at the top and possibly a movable nut lower down. This determines the unplunged height of the motor. Between adjusting the depth rod and this movable nut, it is possible to get fairly fine height settings even though this falls short of proper fine adjustment. You may be able to remove the captive and movable nuts, however, and fit your own home-made fine adjuster. This needs a knob, a box spanner and suitable nut to fit in the end and some epoxy resin to assemble the whole thing. The result is a dramatic improvement in how well your inverted router will operate. Height adjustment becomes extremely easy and precise.

FIG 13.8 A home-made protractor.

Use cramps during assembly to pull the joints up tight. Once set, however, the biscuits will hold the whole thing rigid. The resulting box is the basis of the table.

5 Drill the necessary holes for the machine screws that will hold your router. These positions can be deduced by carefully measuring off the router base. If your router lacks threaded holes, it is possible to make wooden toggles held down by screws which lock the base against the underside of the top.

6 Fit the router. At this stage, if you can, obtain or make a fine depth adjuster to aid fine cutter adjustment (see Fig 13.7).

7 Using the fattest cutter you have, switch on and push it up through the table. The table is now ready for bearing-guided work.

8 Cut a slot for the protractor fence. This needs to be about halfway between the cutter and the front edge of the table, and

FIG 13.9 The reverse side of the fence showing the fitted extraction box.

probably the width of a standard 19mm straight cutter. Unmount your router and make this slot 7–8mm ($^{5}/_{16}$in) deep, with the fence fitted. Take care not to wander off course, because a wobbly slot will make accurate scribing work impossible.

9 The protractor can either be a ready-made metal one, or you can do the job properly and make your own out of ply (see Fig 13.8). Make sure you get a good sliding fit in the slot.

10 Make a fence using strips of ply. The fence facing is 150mm (6in) tall for vertical working and the same length

as the table. It is large enough in the other two directions to be rigid, to allow for cramping down and to give the workpiece adequate support.

11 Fit on to the fence a smaller L-shaped piece thus creating a tunnel shape with four blocks inserted either side of where the cutter will be and at the ends (see Fig 13.9). This stops the tunnel getting choked with dust, and makes extraction from the confined area round the cutter more efficient.

12 From underneath this centre area we now need to remove a piece to allow

FIG 13.10 The floor standing version of the table (open inside to its base). A door is required if you want to contain the mess.

FIG 13.11 An example of a No-Volt Release Switch with a large mushroom shaped 'Off' button.

the cutter through. Use a router T square jig to cut the sides of this hole and the router's own fence to do the lengthwise passes. Then remove the waste piece. When you are working, the fence will be cramped in place using G-ramps.

13 The work hold-downs we shall make also need some cramps to hold them. I have in the past made slots and used wingnuts and bolts for all these functions, but experience shows that slots get worn, threads get damaged and bolts don't always prevent the fence being moved by the force of machining. Cramps are more reliable and easy to remove. The hold-downs we need are 'spring fingers' made from 18mm (³⁄₄in) MDF, and the best way of cutting the slots is on a bandsaw. I tend to do the cuts by eye, but if you use a sliding bevel and measure them out properly you can get neater, more efficient fingers.

14 Extraction is vital. Here a light industrial vacuum cleaner works well, if it has a big enough capacity. A few even have auto-switching for powertools. Then there are proper vacuum extractors, but these can be expensive. Bearing in mind that static routers tend to be left on, even for small fence and cutter adjustments, the vacuum can be left running in the background anyway, so auto-switching isn't all that vital. It is important to fit an extraction hose with a large diameter, because the size of the chippings can be alarming, especially with very large moulding cutters. If you make the whole table as a floor standing unit (see Fig 13.10), the enclosed area can function as a sort of crude 'drop box' giving the large chippings somewhere to fall. With a door fitted, all this

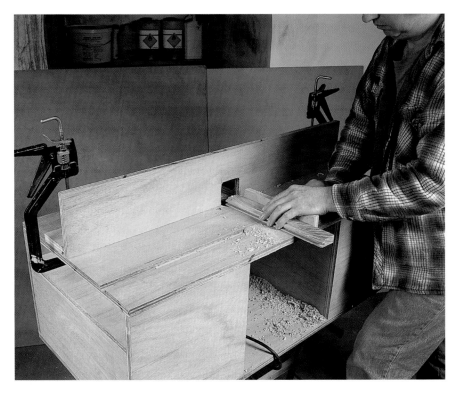

FIG 13.12 The large router table in use. Note how the slot at the end makes clamping that much easier.

mess can be enclosed until emptying time. The extractor still performs a vital role by drawing waste through the fence port.

15 One thing you do need is a NVR (No Volt Release) switch which allows safe, easy switching (see Fig 13.11). It is mounted on the front of the table, unlike the router's own switch which is dangerously inaccessible under the table. The router's own switch can then be left in the on position all the time and the NVR switch used to turn the power on and off. Various companies, such as Axminster Powertools, can supply a suitable one to match the router's motor wattage.

16 The top needs a coat of something shiny such as clear spray lacquer or a neat coat of varnish which can then be waxed to give a degree of 'slip'. Remember that the fence and the protractor need subfences. You can cut a hole in the subfence exactly the shape and size of the cutter being used by setting the cutter to the appropriate depth, switching on and very carefully pivoting the fence forward so that the cutter cuts its way through the subfence. This supports the work right up to the edge of the cut. From time to time, you will also need a tall fence for panel raising and so on. This table, if looked after, should last for some years before you decide you can do better (see Fig 13.12).

14

Board cutting facility

From time to time you will have to cut out material from large manufactured boards such as ply or MDF. Generally these are 2440 x 1220mm (8 x 4ft), though 3050 x 1525mm (10 x 5ft) boards are available. We will concentrate on the former size as this is so common. The arrangement I have described here is not unique or very difficult to make, but simply a common sense solution.

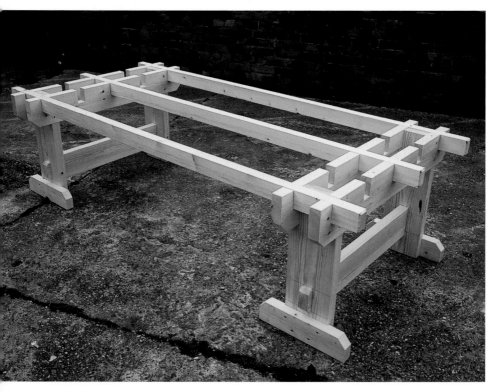

FIG 14.1 The completed board-cutting facility.

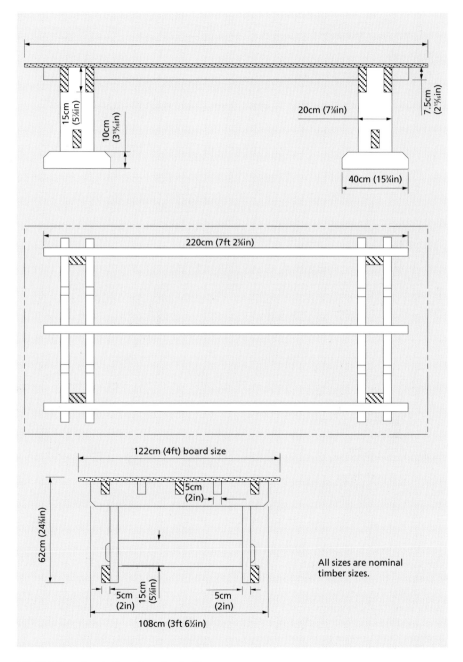

FIG 14.2 Plans for the board-cutting facility.

MATERIALS AND TOOLS

Materials

Prepared (PAR) softwood.

As this is very basic carpentry, width and thickness are expressed as the 'nominal' or sawn sizes. The actual prepared, finished size is always some millimetres smaller. The nominal size is what is normally used at timber yards, while DIY stores tend to label their softwoods at the finished size – 150mm stock at a timber merchant is labelled as 145mm stock at the DIY shop! This is confusing, but timber merchants are helpful and the quality of softwood is generally better. Softwoods are sold in 300mm (12in) increments: 1.8 metres (6ft), 2.1 metres (7ft), 2.4 metres (8ft), 2.7 metres (9ft), and so on

All the lengths shown are at finished size, but allow a bit extra for trimming		
Top rails (4)	1080 x 150 x 50mm	(3ft 6½in x 5⅞ x 1¹⁵⁄₁₆in)
Ends (4)	605 x 200 x 50mm	(23¹³⁄₁₆ x 7⅞ x 1¹⁵⁄₁₆in)
Bottom rails (2)	910 x 150 x 50mm	(2ft 1113/16 x 5⅞ x 1¹⁵⁄₁₆in)
Feet (2)	400 x 100 x 50mm	(15¾ x 3¹⁵⁄₁₆ x 1¹⁵⁄₁₆in)
Support bars (3)	2200 x 75 x 50mm	(7ft 2⅝ x 2¹⁵⁄₁₆ x 1¹⁵⁄₁₆in)
Piece of 9mm MDF for mortising jig		
A few 150mm (5⅞in) nails		
Some 100mm (3¹⁵⁄₁₆in) twinfast screws		

Tools

A hardpoint handsaw or a portable circular saw for cutting parts and making the slots
A 16mm (⅝in) stagger tooth or pocket cutter for mortising (½in shank)
A chamfer cutter for 'improving' all sharp edges
A ½in shank heavy-duty router for mortising, complete with guide bush
A heavy claw hammer
A sharp 38mm (1½in) chisel for chopping out the support rail slots and rounding the tenons

The set-up must hold 2440 x 1220mm (8 x 4ft) sheets. It must hold them flat and it's essential to be able to put the whole thing away so that it doesn't take up precious room in the workshop. The answer would seem to be a modified sawhorse (see Fig 14.1). Sawhorses in pairs give good work support to long timber and they don't take up much space when stacked. However they don't cope so well with boards which can be thin or heavy and prone to sag. The traditional sawhorse also needs to be made correctly, and involves compound angles for the top which has to be 'notched out' to take the legs. There is a bit of skill in putting this basic piece of carpentry kit together.

Instead, I have designed a sawhorse which is much easier to make but works

FIG 14.3 These sawhorses can be stacked to save space.

FIG 14.4 The support rails can be moved for work on narrower boards. Note that all edges have a slight chamfer for a neat finish.

FIG 14.5 A detail of the foot. It is housed to fit over the leg.

perfectly well. Two of them won't 'slide stack' on top of each other, but you can stand one on top of the other for storage (see Fig 14.3). Note how these horses are rather longer than usual – they will give adequate support to the board crosswise, although they are not intended to span the entire width. The slots in each sawhorse which take the lengthwise support rails are the key feature of this set-up.

All the top surfaces are level with each other, and when a full board is placed in the middle there is room all round for cramping a straight edge in place. The additional slots allow you to move the support rails over when you are working with narrower boards (see Fig 14.4). You could of course fit some kind of box underneath to carry bits and pieces, but it will need a lid or it will soon fill up with dust and chips. This set-up works well for home use or for professional routing on site. It has the further advantage of being cheap to make, because it only needs standard prepared softwood.

15

T-square cutting jig

The T-square jig is a basic means of crosscutting and trimming anything to length using the router (see Fig 15.1). The router isn't a substitute for the portable circular saw, but it will give a neat cut and it certainly is handy for fine trimming. It can also be used for cutting housings and dados (these are wide slots), and in Chapter 9, on dovetailing, I suggested a jig like this that has a slot to take a guide bush. This isn't strictly necessary for any cross grain work, including dovetail housings, but it does nonetheless introduce an important element of guidance. Now try a T-square without the slot and discover for yourself how easy or otherwise it really is. The jig is simple enough: the key thing is to make it absolutely square so that it can be relied upon every time.

MATERIALS AND TOOLS

Materials

T square bar	Length variable – 700mm (for trimming of kitchen worktop) 300–400mm (for most other work) x 120 x 9mm MDF or good quality ply (2ft 3⁹∕₁₆ OR 11¹³∕₁₆–15³∕₄ x 4¾ x ⅜in)
Crosspiece for bar	120–200mm long (the longer the better) x 38 x 25mm softwood PAR (finished dimension is usually 34 x 22mm) or same finished size in hardwood (4¾ x 1½ x 1in)
Glue	
Several 25mm (1in) panel pins	

Tools

A straight cutter for trimming the board
A handsaw for cutting the solid wood
2 G-clamps or 2 solo clamps for fixing the T-square to the workpiece and bench when in use

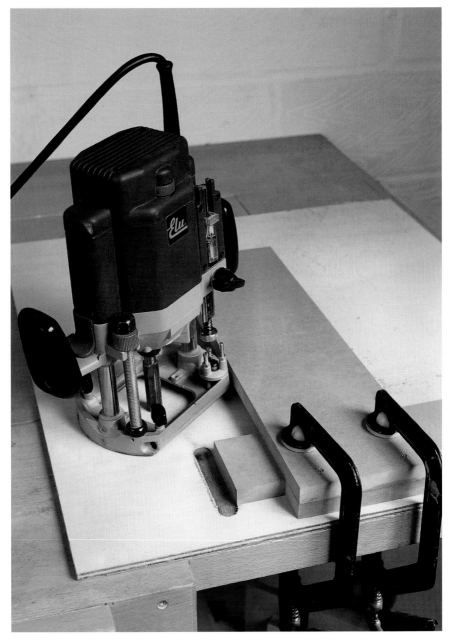

Fig 15.1 The T-square completed and ready to use. Two clamps and a protective board underneath complete the set-up.

Fig 15.2 Details of the cutter and cutter offset written on the T-square.

Method

1 Glue and screw the edge strip on after checking with another square, preferably an engineer's pattern square.

2 For convenience you could write on the blade of the T-square the measurement offset needed when using your standard 'long and strong' cutter (see Fig 15.2). If, for instance, you use a 12.7mm cutter, the offset needed each time you mark out a board is the distance from the cutter's edge to the flat edge of the router base when the cutter is positioned at 90° to the blade of the T-square.

Just remember that if you use a different cutter the offset distance will change, too.

The uses for the T-square are many and various, and include the following:

- trimming boards and worktops (see Fig 15.3)
- cutting shelf ends
- trimming small doors
- making slots
- making housings
- cutting repeat-through mortising where shelves penetrate the carcass sides
- crosscutting with a circular saw
- marking out with a pencil

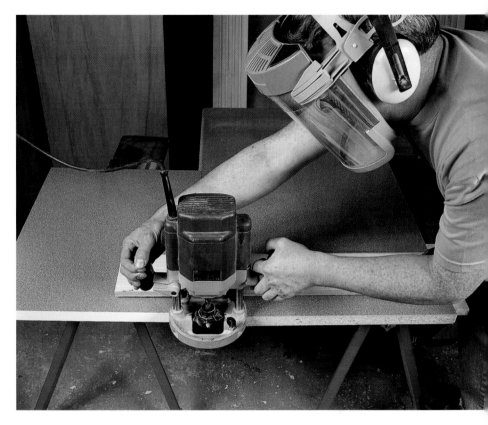

Fig 15.3 Trimming a worktop.

Glossary

Aliphatic resin glue
A glue with a 'high tack rate' for rapid initial bonding.

Arbor
A shank on which cutters, bearings and spacers can be fitted.

Architrave
Moulding applied around a doorway.

Astragal
A small semicircular moulding on a flat strip, often used as a cabinet glazing bar.

Back feeding
Deliberately pushing work the wrong way on a router table. A dangerous practice.

Bead
A half-round shape.

Bolection
A moulding which projects beyond the frame to which it is applied.

Breakout (or tearout)
Torn wood fibres, especially across the grain.

Brushes
Graphite carbon blocks which transmit electricity to a rotating commutator.

Bullnose
A traditional moulding profile.

Cabinetmaking
The construction of furniture.

Carpentry
Applying sawn and prepared timber to buildings.

Cavetto
A cove shape with a small shoulder at each end.

Classical
A common term for a moulding with a cove and roundover with a step in between.

Collet
A split metal sleeve that grips the cutter shank.

Commutator
The sectioned collar on the motor spindle to which each winding is separately connected.

Cornice
A moulding which overhangs the top of a piece of furniture.

Dado
A moulding, fixed low down to protect the wall from furniture and to mark a break in the decor.

Depth turret
A rotating casting on the router base. It has adjustable points so that different plunge depths can be set.

Door lining
The wooden frame in a doorway on which the door is hung.

Door stop
The small strip of wood against which the door shuts.

Drop box
A container situated between the router and the extractor which collects heavy chippings.

Face and edge (UK)
A term denoting the two best adjoining surfaces on prepared wood, marked by a pencil.

Face moulding
A moulding cut into the front surface of the wood.

Fine adjuster
A means of altering the cutter height with great precision.

Fixed-head router
An overhead-mounted machine. The work moves underneath it.

Fixed pilot/guide pin
A round section at the end of a cutter to guide it. Inferior to bearings.

Glazing bar
A wooden bar that separates each pane of glass.

Grain
The general direction or arrangement of the fibrous materials of wood.

Guide bearing
An enclosed ball-bearing race of an exact size. Allows the cutter to follow a shape accurately.

Guide bush
A simple metal collar that keeps the cutter a set distance from the workpiece.

HSE
Health and Safety Executive. In the UK, an agency responsible for safety in industry.

HP or Horsepower
Measure of energy produced at the router spindle or shaft.

HPLV
Small vacuum cleaner-type extractor.

HSS (High Speed Steel)
An alloy of steel, superior to plain carbon steel, which is used for machining applications.

HVLP
High Volume, Low Pressure. A large industrial extraction machine.

Joinery (UK)
Making wood components, such as windows and doors, which are fitted into buildings.

Joinery (US)
Making all furniture and fittings.

Lamb's tongue
An aptly named traditional moulding profile.

Lead-in point
A shaped finger of wood that gives support to curved workpieces.

MDF
Medium density fibreboard. Made with compressed wood fibre and resin.

Micron
A unit of measure used to describe small particles, especially dust from wood.

Motor winding
One of a series of varnished copper electrical wires spun around a steel core.

Ogee
A classical moulding consisting of a concave and convex form.

PAR
'Prepared All Round.' Timber that is planed on all four surfaces.

PVA
Polyvinyl Acetate. A cheap and reliable glue for ordinary use.

Per cube foot (UK)
How hardwoods are still sold in the UK.

Per metre run (UK)
How softwood is sold.

Picture rail
A revived moulding, placed high up on the wall and used to hang picture frames.

Planted moulding
A moulding which is applied to existing woodwork.

Polyurethane glue
A glue which foams slightly on application, sets quickly, and can be used on wet wood.

Pre-scoring
A very shallow cut slicing the wood fibres, thus preventing tearout when deep cutting.

Rising cutter
When a heavy cut causes a cutter to slide out of a worn collet.

Roller guide
A device to make a router follow irregular shapes.

Roller stands
Supports for wood as it enters and leaves a machine table.

Sawn timber
Timber that has been cut into usable sections, but requires proper planing before it can be used.

Sealed bearings
These are superior to ordinary ballraces. They are designed for high-speed work and keep out the dust.

Shank
A precision-machined plain section on the cutter that slides into the collet.

Shaw guard
A type of combined hold-down and guard for safe working on woodworking machines.

Skis
Metal strips which support the router above the work so that it can move over uneven areas.

Skirting
A large, moulded strip that decorates and finishes a wall where it meets the floor.

Sprung fingers
A hold-down that uses thin fingers or tines to press wood against the fence.

Superglue
An adhesive. It contains cyanoacrylate and is useful for instant minor wood repairs.

TCT (Tungsten Carbide Tipped)
A type of cutter. Tungsten carbide is a metal alloy used for cutting abrasive materials.

Through fence
A wooden facing completely covering the cutter gap in the existing table fences.

Timber (Lumber in the US)
Felled trees, partly converted or unconverted for use.

Torus top
A skirting top moulding featuring a half-round shape.

Trammel
A point and arm for drawing or cutting circles.

Tufnol
Industrial sheet material suitable for jigmaking, etc.

Twinfast
A type of modern screw with a parallel shank and two driving threads.

Urea formaldehyde glue
An adhesive which sets hard and is good for filling gaps.

Veneer
A wafer-thin sheet of wood (0.6mm thick approx.) usually glued to a board.

Veneer pins
Tiny pins, thinner than panel pins. Useful for neat, split-free fixings.

Watts
Expression of a router's electrical consumption and output.

MEASUREMENTS

Although care has been taken to ensure that imperial measurements are true and accurate, they are only conversions from metric. Care should be taken to use either imperial or metric measurements consistently.

METRIC CONVERSION TABLE

inches to millimetres and centimetres mm = millimetres cm = centimetres

inches	mm	cm	inches	cm	inches	cm
⅛	3	0.3	9	22.9	30	76.2
¼	6.4	0.6	10	25.4	31	78.7
⅜	9.5	1.0	11	27.9	32	81.3
½	12.7	1.3	12	30.5	33	83.8
⅝	16	1.6	13	33.0	34	86.4
¾	19	1.9	14	35.6	35	88.9
⅞	22	2.2	15	38.1	36	91.4
1	25	2.5	16	40.6	37	94.0
1¼	32	3.2	17	43.2	38	96.5
1½	38	3.8	18	45.7	39	99.1
1¾	44	4.4	19	48.3	40	101.6
2	51	5.1	20	50.8	41	104.1
2½	64	6.4	21	53.3	42	106.7
3	76	7.6	22	55.9	43	109.2
3½	89	8.9	23	58.4	44	111.8
4	102	10.2	24	61.0	45	114.3
4½	114	11.4	25	63.5	46	116.8
5	127	12.7	26	66.0	47	119.4
6	152	15.2	27	68.6	48	121.9
7	178	17.8	28	71.1	49	124.5
8	203	20.3	29	73.7	50	127.0

About the author

Anthony Bailey has had several career changes which have channelled his skills firmly in the direction of woodworking. He trained originally as a professional photographer, then spent several years working as a furniture restorer and most recently as a cabinetmaker. Anthony has written for various woodworking magazines and has been a demonstrator at several woodworking shows. He likes to impart his knowledge and enthusiasm, and putting his thoughts into a book was the logical next step. Anthony is currently chief photographer for the GMC Group and consulting editor of *The Router*. He is married with four young children, and enjoys the family's support in all his enterprises.

Index

aluminium cutters 66

back feeding 17
base, router 10–11, 72
bead cutters 58–9
bearing-guided cutters 74–5, 79,
 105, 106
bearings, replacing 35
bevel cutters 61, 79
biscuit jointing 119–21, 145–6
 using a biscuit jointer 119–20
 using a router 120–1
board cutting facility 150–3
brushes, changing 34–5
'built-out' fence 102

carving 78–9
cases, router 20–1
 portable storage case 134–7
chamfer cutters 61
chippings 37
circuit breakers 30
collets 9, 41, 43
corebox cutters 54–5
Corian cutters 65, 66
cornice cutters 64
cove cutters 54–5
cramping 110, 118, 148
crosshair sights 90
customized cutters 67
cutter selection boards 130–3
cutters 9, 34, 46–69
 care 41–2
 changing 14
 cleaning 43
 freehand work 80–1
 honing 43
 manufacture 42–3, 46–9
 reground 43–4
 safety 41–4
 selection and use 41
 sets of 67–9
 shank problems 43

specials 65–7
storing 43
types 49–65

decorative cutters 59
depth setting 15–16, 44–5
depth-setting rod 10
die-stamped cutters 46
direction of cut 16–17, 38, 39
disposable-tip cutters 48–9
dolls' house 82, 85–6
dovetail cutters 61–2
dovetailing 122–7
 clever jigs 123–5
 housings 126–7
 using a jig 123
down shear cutters 50
drawer joints 118
drawer pull cutters 65, 66
drill bits 66–7
drilling, precision 89–90
'drop on' machining 103–4
dust extraction 11, 12, 28, 37–8, 99,
 147, 148–9

ear defenders/plugs 32
edge cutters 59
edge moulding 100–2
edge planing 73–4, 107
electrical work 30
electronics 9, 34–5
ergonomics 20
extraction 11, 12, 28, 37–8, 99,
 147, 148–9
eye protection 32–3

face and edge marks 108–9
face moulds 62–3
featheredge 75
fence
 'built-out' 102
 straight fence 70–2
 supporting 72, 73

through–fence 98–9
fence lock knobs 37
fence rods 72
fine adjuster 146
fixed–base routers 6, 7, 13
freehand work see handheld operations

glueing 110–11
guide rails 77

half-inch collet router 45
half lap joint 114–15
hand router 5
handheld operations 70–81
 bearing-guided cutters 74–5
 cutters 80–1
 edge planing 73–4
 narrow edges 72–3
 roller guides 77–8
 router carving 78–9
 safety 39–41
 straight fence 70–2
 straightedge and guide rail 75–7
 templates 85–6
 trimming laminates and profiles
 79–80
heating 31
heavy-duty routers 12
hinge jigs 91–2
hinge recesser 50–1
hinge sinkers 67
hold-downs 99–100, 148
honing cutters 43
housings, dovetail 126–7
HSS cutters 42, 46–7

Incra Ultra jig 123–4
inverted routing see router spindle;
 router tables

jigs 82–95
 dovetailing 123–5
 hinge jigs 91–2
 lock mortises 93–5
 precision drilling 89–90
 strip jig 132
 T-square jig 126, 154–7
 worktop jointing 87–9
jointing 108–21
 basics 108–11
 biscuit jointing 119–21, 145–6
 dovetailing 122–7
 half lap 114–15
 lock mitre or drawer joint 118
 mortise and tenon 116–17

profile and scribe 104–5
 rebate 114
 tongue and groove 111–14
 worktops 87–9
jointing cutters 60

kits 20–1

laminate trimmer 12–13, 80
laminates, trimming 79–80
large router table 142–9
lead 37
lead-in point 83–4
Leigh dovetail jig 124–5
light 29
light-weight routers 11
linenfold cutters 66, 67
lock mitre joint 118
lock mortises 93–5
lubricating plunge columns 35–6

marking up 108–9
MDF 87
medium–duty routers 12
metric conversion table 162
miniature cutters 63
mortise box 116, 117
mortise and tenon joints 116–17
mortises, lock 93–5
motor 8–9
multi-form cutters 48
multiple passes 10, 44

name plaque 83–4
narrow edges 72–3
No Volt Release (NVR) switch
 148, 149
noise 28–9, 32

ogee cutters 64–5
operational safety 38–41
outdoor working 26–9
ovolo/roundover cutters 54

panel cutters 62–3
personal safety 32–3
pierce and trim cutter 80
pin-guided cutters 54
planing, edge 73–4, 107
plug 36
plunge columns 9–10
 lubricating 35–6
plunge lock 9–10
plunge routers 6–7, 8–12
polycrystalline diamond (PCD)

cutters 48
portable extractors 38
portable router storage case 134–7
power supply 29–30, 31
precision drilling 89–90
price 21
professional routers 11
profile and scribe cutters 62
profile and scribe jointing 104–5
protractor fence 146–7

quality 21

rebate cutters 55–6
rebates 105–7, 114
reed cutters 58–9
reground cutters 43–4
reliability 22
respirators 33
roller guides 77–8
roundover/ovolo cutters 54
router 2–17
 power 5–7, 19
 size 11–12, 19, 44
 starting to use 14–17
 types 7–13
 uses 2–4
Router Mat 40, 41
router safety 34–45
 cutter safety 41–4
 depth setting 44–5
 machine size 44
 multiple passes 44
 operational safety 38–41
 safety checks 36–8
router selection 18–25
 ergonomics and handling 20
 kits and cases 20–1
 price vs quality 21
 reliability 22
 servicing and spares 22
 size and power 19
 system extendability 19
 warranties 22
router spindle 96, 100–7
 'built-out' fence 102
 'drop on' machining 103–4
 edge moulding 100–2
 edge planing 107
 profile and scribe jointing 104–5
 slotting and rebating 105–7
router tables 41, 81, 96–100
 large 142–9
 small 138–41

safety 26–45
 outdoors 26–9
 personal 32–3
 router see router safety
 workshop 29–31
sanding 111, 133
sawhorses 152–3
servicing 22
Shaw guard 100
shims 112–13
side profile cutters 65
single-flute straight cutters 50
skis 80
slot cutters 64
slotting 105–7
small router table 138–41
spares 22
specialist routers 12–13
speed 5–6, 14, 15
sprung finger hold–down 100
stagger tooth cutters 50, 51, 93, 94
stop blocks 103
'stopped' face moulding 103–4
straight cutters 49–53
straight fence 70–2
straightedge 75–7
strip jig 132
supporting the work 27, 28
switches 34, 148, 149
system extendability 19

T-square cutting jig 126, 154–7
TCT cutters 42–3, 46, 47–8
templates 82–95
 freehand work 85–6
 name plaque 83–4
through-fence 98–9
tongue and groove joint 111–14
trammel 138, 139, 145
trimmers 56–8
trimming 79–80
tunnel 107
turret stop 10
two-flute straight cutters 50

V-groove cutters 61
vernier callipers 108, 109
volatile substances 31

warranties 22
Woodrat 125
workbench 31
workshop safety 29–31
worktop jointing 87–9

A SELECTION OF TITLES AVAILABLE FROM

GMC Publications

BOOKS

WOODCARVING

The Art of the Woodcarver — GMC Publications
Beginning Woodcarving — GMC Publications
Carving Architectural Detail
in Wood: The Classical Tradition — Frederick Wilbur
Carving Birds & Beasts — GMC Publications
Carving the Human Figure:
Studies in Wood and Stone — Dick Onians
Carving Nature: Wildlife Studies
in Wood — Frank Fox-Wilson
Carving Realistic Birds — David Tippey
Decorative Woodcarving — Jeremy Williams
Elements of Woodcarving — Chris Pye
Essential Woodcarving Techniques — Dick Onians
Lettercarving in Wood:
A Practical Course — Chris Pye
Making & Using Working Drawings
for Realistic Model Animals — Basil F. Fordham
Power Tools for Woodcarving — David Tippey
Relief Carving in Wood:
A Practical Introduction — Chris Pye
Understanding Woodcarving — GMC Publications
Understanding Woodcarving in
the Round — GMC Publications
Useful Techniques for Woodcarvers
— GMC Publications
Wildfowl Carving – Volume 1 — Jim Pearce
Wildfowl Carving – Volume 2 — Jim Pearce
Woodcarving: A Complete Course — Ron Butterfield
Woodcarving: A Foundation Course — Zoë Gertner
Woodcarving for Beginners — GMC Publications
Woodcarving Tools & Equipment
Test Reports — GMC Publications
Woodcarving Tools, Materials
& Equipment — Chris Pye

WOODTURNING

Adventures in Woodturning — David Springett
Bert Marsh: Woodturner — Bert Marsh
Bowl Turning Techniques Masterclass — Tony Boase
Colouring Techniques for Woodturners — Jan Sanders
Contemporary Turned Wood:
New Perspectives in a Rich Tradition
— Ray Leier, Jan Peters & Kevin Wallace
The Craftsman Woodturner — Peter Child
Decorating Turned Wood:
The Maker's Eye — Liz & Michael O'Donnell
Decorative Techniques for Woodturners
— Hilary Bowen

Fun at the Lathe — R.C. Bell
Illustrated Woodturning Techniques — John Hunnex
Intermediate Woodturning Projects
— GMC Publications
Keith Rowley's Woodturning Projects
— Keith Rowley
Making Screw Threads in Wood — Fred Holder
Turned Boxes: 50 Designs — Chris Stott
Turning Green Wood — Michael O'Donnell
Turning Miniatures in Wood — John Sainsbury
Turning Pens and Pencils
— Kip Christensen & Rex Burningham
Understanding Woodturning — Ann & Bob Phillips
Useful Techniques for Woodturners
— GMC Publications
Useful Woodturning Projects — GMC Publications
Woodturning: Bowls, Platters, Hollow
Forms, Vases, Vessels, Bottles, Flasks,
Tankards, Plates — GMC Publications
Woodturning: A Foundation Course
(New Edition) — Keith Rowley
Woodturning: A Fresh Approach — Robert Chapman
Woodturning: An Individual
Approach — Dave Regester
Woodturning: A Source Book of Shapes
— John Hunnex
Woodturning Jewellery — Hilary Bowen
Woodturning Masterclass — Tony Boase
Woodturning Techniques — GMC Publications
Woodturning Tools & Equipment
Test Reports — GMC Publications
Woodturning Wizardry — David Springett

WOODWORKING

Advanced Scrollsaw Projects — GMC Publications
Beginning Picture Marquetry — Lawrence Threadgold
Bird Boxes and Feeders for the Garden
— Dave Mackenzie
Complete Woodfinishing — Ian Hosker
David Charlesworth's Furniture-
Making Techniques — David Charlesworth
David Charlesworth's Furniture-Making
Techniques – Volume 2 — David Charlesworth
The Encyclopedia of Joint Making — Terrie Noll
Furniture-Making Projects for
the Wood Craftsman — GMC Publications
Furniture-Making Techniques for
the Wood Craftsman — GMC Publications
Furniture Projects — Rod Wales
Furniture Restoration (Practical Crafts)
— Kevin Jan Bonner

Furniture Restoration: A Professional
at Work John Lloyd
Furniture Restoration and Repair
for Beginners Kevin Jan Bonner
Furniture Restoration Workshop Kevin Jan Bonner
Green Woodwork Mike Abbott
The History of Furniture Michael Huntley
Intarsia: 30 Patterns for the Scrollsaw John Everett
Kevin Ley's Furniture Projects Kevin Ley
Making & Modifying Woodworking
Tools Jim Kingshott
Making Chairs and Tables GMC Publications
Making Chairs and Tables
– Volume 2 GMC Publications
Making Classic English
Furniture Paul Richardson
Making Heirloom Boxes Peter Lloyd
Making Little Boxes from Wood John Bennett
Making Screw Threads in Wood Fred Holder
Making Shaker Furniture Barry Jackson
Making Woodwork Aids and Devices
 Robert Wearing
Mastering the Router Ron Fox
Minidrill: Fifteen Projects John Everett
Pine Furniture Projects for the Home
 Dave Mackenzie
Practical Scrollsaw Patterns John Everett
Router Magic: Jigs, Fixtures and Tricks
to Unleash your Router's Full Potential Bill Hylton
Router Tips & Techniques GMC Publications
Routing: A Workshop Handbook Anthony Bailey
Routing for Beginners Anthony Bailey
The Scrollsaw: Twenty Projects John Everett
Sharpening: The Complete Guide Jim Kingshott
Sharpening Pocket Reference Book Jim Kingshott
Simple Scrollsaw Projects GMC Publications
Space-Saving Furniture Projects Dave Mackenzie
Stickmaking: A Complete Course
 Andrew Jones & Clive George
Stickmaking Handbook
 Andrew Jones & Clive George
Storage Projects for the Router GMC Publications
Test Reports: The Router and Furniture &
Cabinetmaking GMC Publications
Veneering: A Complete Course Ian Hosker
Veneering Handbook Ian Hosker
Woodfinishing Handbook (Practical Crafts)
 Ian Hosker
Woodworking with the Router: Professional
Router Techniques any Woodworker
can Use Bill Hylton & Fred Matlack
The Workshop Jim Kingshott

UPHOLSTERY
The Upholsterer's Pocket
Reference Book David James

Upholstery: A Complete Course
(Revised Edition) David James
Upholstery Restoration David James
Upholstery Techniques & Projects David James
Upholstery Tips and Hints David James

TOYMAKING
Restoring Rocking Horses
 Clive Green & Anthony Dew
Scrollsaw Toy Projects Ivor Carlyle
Scrollsaw Toys for All Ages Ivor Carlyle

VIDEOS

Drop-in and Pinstuffed Seats David James
Stuffover Upholstery David James
Elliptical Turning David Springett
Woodturning Wizardry David Springett
Turning Between Centres: The Basics Dennis White
Turning Bowls Dennis White
Boxes, Goblets and Screw Threads Dennis White
Novelties and Projects Dennis White
Classic Profiles Dennis White
Twists and Advanced Turning Dennis White
Sharpening the Professional Way Jim Kingshott
Sharpening Turning & Carving Tools Jim Kingshott
Bowl Turning John Jordan
Hollow Turning John Jordan
Woodturning: A Foundation Course Keith Rowley
Carving a Figure: The Female Form Ray Gonzalez
The Router: A Beginner's Guide Alan Goodsell
The Scroll Saw: A Beginner's Guide John Burke

MAGAZINES

WOODTURNING ◆ WOODCARVING
FURNITURE & CABINETMAKING
THE ROUTER ◆ WOODWORKING
THE DOLLS' HOUSE MAGAZINE
WATER GARDENING
OUTDOOR PHOTOGRAPHY
BLACK & WHITE PHOTOGRAPHY
BUSINESSMATTERS

All are available direct from the Publishers or through bookshops, newsagents and specialist retailers.
To place an order, or to obtain a complete catalogue, contact:

GMC Publications,
Castle Place, 166 High Street, Lewes, East
Sussex BN7 1XU, United Kingdom
Tel: 01273 488005 Fax: 01273 478606
E-mail: pubs@thegmcgroup.com
Orders by credit card are accepted